Books are to be returned on or before
the last date below.

Exhibition
Catalogue.

argos editions

Kunsthalle Bern

Mark Lewis

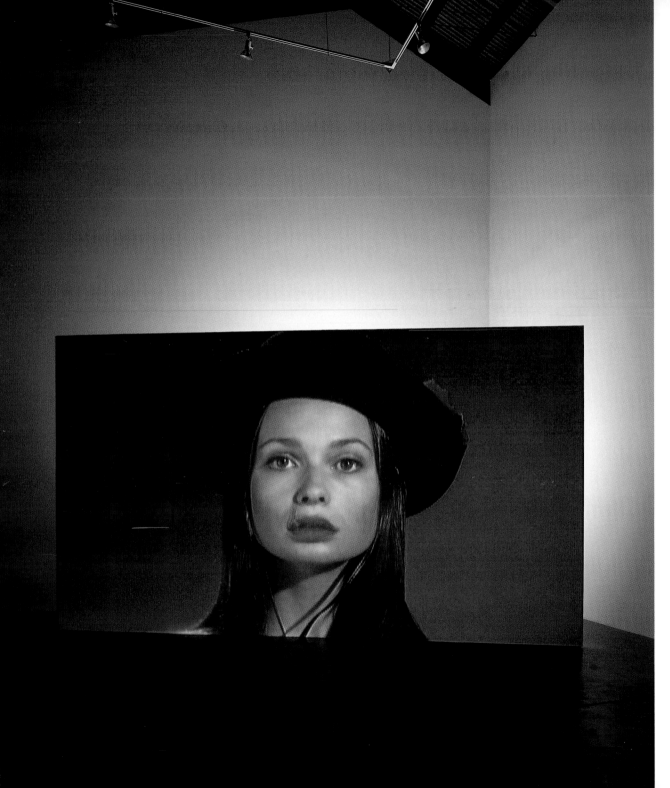

Envers et contre le cinéma.
Sur les films de Mark Lewis

Jean-Michel Bouhours

En 1971, dans la revue américaine *Artforum*, le photographe et cinéaste Hollis Frampton affirmait dans une perspective historicisante : « aucune activité ne devient un art avant que son époque ne soit terminée et que sa fonction d'aide à la simple survie ne tombe dans une vétusté totale »[1]. Cette affirmation globalisante venait soutenir une approche visionnaire de l'histoire du cinéma. La fin annoncée du cinéma par Frampton il y a trente ans et reprise aujourd'hui par de nombreux artistes contemporains qui forment ce que l'on nomme « un effet cinéma » est par conséquent la fin d'un cinéma comme art de masse, à qui est revenu la tâche quasi exclusive de divertir les foules pendant au moins un demi-siècle.

Venant de la photographie, Mark Lewis s'est tourné vers le cinéma à partir du milieu des années 90 ; ses films s'inscrivent dans cet « effet cinéma », où le cinéma n'est plus appréhendé dans une vision méta-historique, comme le fit Frampton, mais comme instrument d'une sédimentation mnémorielle collective. Elève de Victor Burgin et de Laura Mulvey, théoricienne qui dès le milieu des années 70 a transgressé avec une grande acuité les clivages idéologiques des cinémas à la marge, Lewis conçoit son propre travail comme dépassement de ces catégories héritées de la modernité que sont Industrie/Avant-garde. Ses films prônent comme *modus operandi* les moyens de tournage de l'industrie (35mm, équipe technique, acteurs, production) où, dans le contexte d'un travail collectif, le réalisateur assiste à sa propre désappropriation. Lewis réintroduit par ce mode opératoire le hasard, qu'un Man Ray recherchait au contraire en improvisations.

Cinéma post-moderne, cinéma d'après la fin du cinéma comme industrie dominante du spectacle, Lewis reproduit jusqu'à la caricature les ficelles stylistiques du cinéma hollywoodien.

A Different Take on Cinema:
Films by Mark Lewis

In a 1971 issue of *Artforum*, the American photographer and filmmaker Hollis Frampton put matters into historical perspective by asserting that an activity only becomes an art once its era is over and its role as an aid to mere survival is totally obsolete.[1] This sweeping assertion was prescient with respect to the history of cinema: Today, numerous contemporary artists adhering to what is termed the "cinema effect" uphold the end of cinema as foreseen by Frampton thirty years ago; the end, that is, of cinema as an art of the masses and almost exclusively responsible for entertaining the general public during over half a century.

Mark Lewis turned from photography to filmmaking during the mid-'90s. He has since been producing film works in the "cinema effect" line that turns its back on Frampton's metahistorical outlook and focuses instead on cinema as the instrument of a collective, mnemonic process of sedimentation. Having studied with both Victor Burgin and Laura Mulvey, Lewis is familiar with the latter theoretician's shrewd transgression of the boundaries between various fringe film ideologies. However, his own approach goes beyond such categories bequeathed to us by modernism under the headings "commercial" or "avant-gardist." His chosen *modus operandi* is to avail himself of the resources of professional filmmaking (35-mm film, professional cast, camera crew and production team), entailing a collective effort where the film director stands witness to his own takeover. In this way, Lewis reintroduces the random element, which someone like Man Ray sought out instead through experiments in improvisation.

In his post-modern film works – works postdating the end of cinema as the choice medium of mass entertainment – Lewis goes so far as to caricature the stylistic tricks of the Hollywood film trade. Yet, because they tend to eschew

1. Frampton, Hollis: "For a Metahistory of Film: Commonplace Notes and Hypotheses". in *Artforum*, September 1971, pp.33-35.

1. Hollis Frampton, « Pour une métahistoire du film »,
in Hollis Frampton, *L'écliptique du savoir* (Annette Michelson et Jean-Michel Bouhours éd.),
Paris, Centre Pompidou, 1999.

Pourtant l'absence de trame narrative de ses films, souvent leur dé-linéarité, en font des produits de consommation culturelles réservés au monde de l'art contemporain et de la cinéphilie éclairée.

linearity, let alone a narrative framework, his films represent cultural consumer goods reserved for a more restricted public of contemporary art and art-house film enthusiasts.

The narrator figure

In his film *The Pitch*, a high-angle shot focuses on Lewis himself, as he holds forth to viewers in defense of the film industry's lower status employees. He points out the ways in which extras are exploited, their lack of freedom and the ambiguity of their status, and underscores the gap between their presence – both physically and on screen – and their absence as psychologically valid individuals. Lewis chose to shoot the film in a train station concourse, which the camera discloses by tracking it from a close-up to a full wide-angle shot, a cinematic device that translates into visual terms all that he decries in his speech. While watching Lewis in his speechifying role, we gradually discover various train travelers in his vicinity – anonymous figures apparently unaware of what is going on – as they come and go, stopping to check the notice boards in line with the camera shot. The imagery joins thesis to antithesis. Indeed, all the while Lewis so earnestly lectures us about the anonymous screen figures, his cinematic device allegorically recreates the joint presence of the narrating artist/demiurge on the one hand and the anonymous bit players on the other. The fact that we take so little notice of the latter reduces them to the status of accessories ("extra"), implying that our gaze tends to be mercilessly selective, and that this is the price we pay for our capacity to interpret.

The paradox inherent in the ideological discourse comes through most explicitly in the very context that he takes on. The film setting represents another unifying symbolic device to Lewis, which he challenges with his 1999 film *Centrale*. We see a woman, a man, one field of vision set against an artificial field of vision, instilling a spatial discontinuity that plays havoc with the alleged reality of the setting.

Cinema povera vs. commercial cinema

Lewis begins his movie *A Sense of the End* (1996) by quoting the experimental filmmaker Stan Brakhage's motion pictures: The film opens with several hand-painted film frames and then the title "The End" etched right into the film stock, calling to mind the dance-patterned writing of the opening credits for Brakhage's *Dog Star Man* (1964). Following immediately upon this sequence, suggestive of underground cinema, comes a remake of the ending to a typical Hollywood tragedy: A mortally wounded man collapses and the words "The

La figure du narrateur

Dans *The Pitch*, Mark Lewis est lui-même en scène, face à la caméra en plongée. Il harangue les spectateurs prenant la défense d'un sous-prolétariat de l'industrie, les figurants. Lewis fait valoir leur exploitation, leur absence de liberté et l'ambiguïté de leur statut, entre la présence (physique à l'écran) et l'absence (en tant qu'individus ayant une psychologie). Mark Lewis a choisi comme lieu de tournage un hall de gare que la cadrage d'un plan serré vers un plan large nous fait découvrir progressivement. Mark Lewis a choisi un dispositif qui permet de reproduire visuellement ce que le discours est en train de dénoncer. Nous découvrons progressivement qu'autour de la figure de Lewis dans le rôle du discoureur, des usagers anonymes et vraisemblablement inconscients de ce qui se trame, vont et viennent, s'arrêtent, regardent des panneaux d'affichage placés dans le même axe que la caméra. Thèse et antithèse sont ainsi réunis à l'image. Pendant que Lewis parle avec conviction de ces anonymes de l'écran, le dispositif recrée de manière allégorique cette co-présence de l'artiste narrateur et démiurge et des anonymes, dont la présence à peine remarquée est réduite à l'accessoire. Il s'agit de l'impitoyable sélectivité de notre regard, prix de notre capacité d'interprétation.

Le paradoxe du discours idéologique apparaît très clairement dans le contexte même qu'il combat. Le cadre cinématographique est un autre dispositif symbolique unifiant auquel Lewis s'attaque avec *Centrale* (1999). Une femme, un homme, un champ contre champ factice, dans une discontinuité spatiale viennent contrecarrer la véracité supposée du cadre.

Cinema povera vs. cinéma industriel

Dans *A Sense of the End* (1996), Lewis commence par une citation du cinéma de Stan Brakhage ; quelques images peintes directement sur la pellicule puis un « The End » gravé à même la pellicule évoquent l'écriture dansante des génériques de l'auteur de *Dog Star Man* (1964).

A Sense of the End, 1996, film still

6

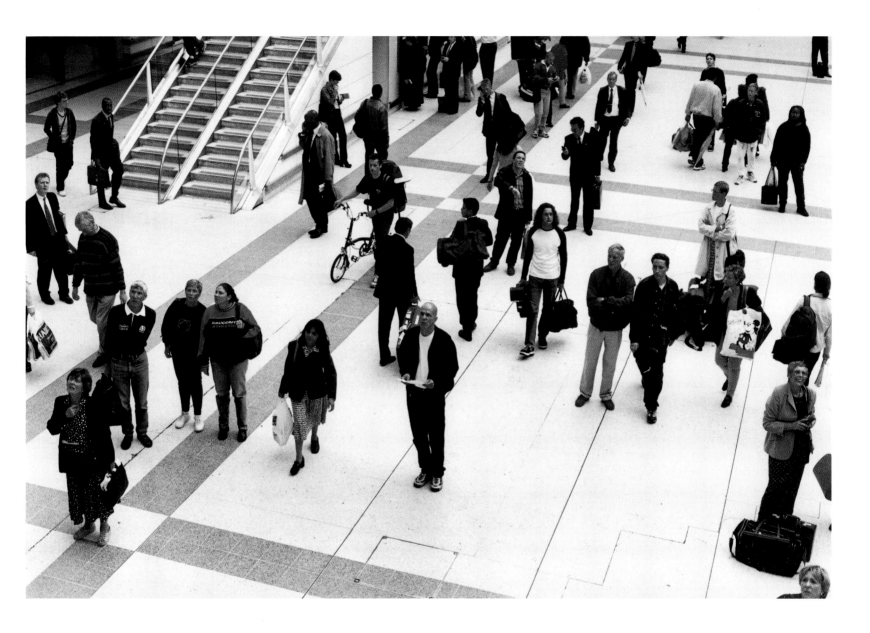

The Pitch, 1998,
production still

Cette séquence évoquant le cinéma underground est immédiatement suivie du « remake » d'une fin (de film) hollywoodienne tragique la plus courante : un homme court, blessé à mort, s'écroule ; le mot « fin » apparaît dans l'image, grossit dans le cadre, sanctifiant celle-ci comme image ultime et indépassable formant l'acmé de la diégèse. A chaque film sa fin et pourtant ce que montre le film de Lewis, ce sont leurs extraordinaires stéréotypes. Chaque genre a sa fin, devrait-on dire : la fin d'un film hollywoodien n'est pas la fin d'une série télévisée ; le générique de fin prend le pas sur l'image différemment ; à chaque catégorie correspond un genre musical. Notre capacité de décodage des genres, et par voie de conséquence notre propre formatage, saute aux yeux ! Avec *A Movie* (1958) Bruce Conner cherchait aussi à reproduire un mode d'écriture télévisuelle, celle des actualités télévisées basées sur des enchaînements non diégétiques. La catastrophe côtoie l'événement heureux, le drame, la comédie, reflétant une actualité faite d'événements composites sans relations entre eux si ce n'est leur concomitance. Dans le cas de Bruce Conner comme dans celui de Mark Lewis, il s'agit de reproduire au plus près un langage cinématographique ou télévisuel, qui aliène le récepteur. Le premier « récupère » des images de films scientifiques ou d'actualités, fait du *ready made* cinématographique parce que cela coûte moins cher mais aussi, comme le souligne Craig Baldwin, auteur du film de compilations *Tribulations 99* (1991), parce que « c'est en accompagnant le courant assez longtemps qu'on en modifie le cours » ; projet idéologique d'un anti-art basé sur le parasitage de mass media dont l'artiste tente de relever le défi. Ces travaux sont ceux d'une anamnèse, que Jean-François Lyotard compare au travail psychanalytique consistant à régler « le trouble présent en associant librement des éléments apparemment inconsistants avec des situations passées »[2]. Ce travail d'anamnèse et d'anagogie s'opère dans un contexte où l'artiste est exclu de l'économie capitaliste ; le recours au *ready made*, à un junk art, art de la récupération et du collage ou assemblage, est cependant la seule possibilité (économiquement parlant) de faire des films. Cette double nécessité n'a plus cours chez des artistes comme Mark Lewis parce que le marché de l'art est capable aujourd'hui de supplanter la production cinématographique commerciale et d'inventer des règles de « retour sur investissement » parfaitement inédits. Mark Lewis n'emprunte pas d'images existantes ; il les recrée sur le mode du pastiche, non pas comme l'intégralité d'un film reconstruit (*remake*) mais comme copie minutieuse des ficelles du cinéma ou de la télévision commerciale (*A Sense of the End*) ou interprétation personnelle du film de Michael Powell *Peeping Tom* (1959). Reprenant la métaphore psychanalytique, nous dirions qu'il répète la névrose moderne. Mais cette répétition est sujette à un déplacement, à la distanciation de l'objet de son contexte du divertissement vers celui de l'art.

End" sweep across the image. These words expand as if to sanctify the image as the ultimate scene to end all scenes that brings the diegesis to its peak. To each film, its ending. Yet Lewis's film shows how clichéd all such endings are, so that we might better say: to each category, its ending. The end of a Hollywood-style film is not the same as for a television series: The credits override the image differently, and a special kind of music goes with each. Our capacity for decoding the different categories – and by the same token, our own formatting – is there for all to see! In his 1958 film *A Movie*, Bruce Connor, another master of the found footage form, also sought to replicate a TV-like writing style as taken from TV news broadcasts based on extradiegetic sequences of events. Catastrophes mix with joyous happenings, dramas with comedies, mirroring news made of composite events totally unrelated to each other lest it be by their concomitance. Like Lewis, Conner focuses on duplicating as closely as possible the sort of cinematographic or televisual language that alienates the public on the receiving end. He does so by "recycling" film images taken from broadcasts featuring the news or scientific findings. He resorts to these cinematographic "readymades" because it costs less. And also – as asserted by the underground filmmaker Craig Baldwin, author of the audio/visual collage film *Tribulations 99* (1991) – because it is only by riding with a current long enough that you get to change its course. His is an ideological platform for anti-art, whereby the artist sponges on today's mass media in an endeavor to meet the challenge posed by the latter. These are works that entail anamnesis, which Jean-François Lyotard compares to the psychoanalytic process of dealing with present turmoil by freely associating various flimsy elements with past situations.[2] Works developed along such anamnestic and anagogic lines are carried out in a context where artists are excluded from the capitalist economy. Yet, it is only by resorting to readymades, junk art, the art of recycling and collage or assemblage that, financially speaking, artists working in this vein are able to make films. This conundrum no longer holds true for artists such as Lewis, since today's art market is in a position to supplant commercial motion picture production and come up with its own, heretofore unheard of "return on investments" rules. Lewis does not borrow existing images but, rather, recreates them in the form of pastiches. It is no remake of an entire movie that he creates, but a painstaking copy of the tricks of the trade used in commercial motion pictures and

2. Jean-François Lyotard, *The Post Modern Explained to Children*, London, Turnaround, 1992.

2. Jean-François Lyotard, *Le Post-moderne expliqué aux enfants*, Paris, Galilée, 1988.

Mark Lewis réfute le topos de la salle de cinéma, héritage du dispositif spectaculaire théâtral. Quand le milieu de l'art a envisagé ce qu'Umberto Eco a dénommé l'œuvre ouverte dont le spectateur serait dorénavant un élément actif, ce dispositif de la salle parut autoritaire et dépassé et donc remis en cause. Le syncinéma de Lemaître revendiquait en 1951 un lieu élargi ouvert sur l'espace public comme condition d'un prosélytisme révolutionnaire créant les conditions d'une société « paradisiaque ». Dans le grand mouvement né au milieu des années 60, où le cinéma se pensait élargi – *expanded cinema*[3] diront les anglo-saxons – certains cinéastes, comme Jordan Belson ou Stan Vanderbeek, rêvaient d'architectures utopiques globalisantes où l'espace de vision deviendrait un véritable espace d'une conscience supérieure. L'art contemporain actuel attire le cinéma dans ses espaces dévolus, que sont les espaces des musées ou des galeries. *Black box* ou *white cube* semblent les positifs et négatifs de dispositifs où le spectateur est un promeneur. Le cinéma ne revendique plus son déroulement du début jusqu'à la fin et qui, comme le faisait remarquer Christian Metz, ancrait le cinéma au récit et le démarquait phénoménologiquement du monde réel.

Cinéma continu, cinéma sans limites temporelles. En dehors des films de fiction assujettis au standard des 90 ou 100 minutes, les autres cinématographies se sont donné la durée qui leur était nécessaire. L'expérience du cinéma structurel nous a presque habitué à ce que la durée du film corresponde à la durée d'un processus mis en œuvre. *Algonquin Park, September* (2001) offre de ce point de vue une fin sans dénouement : la petite barque qui émerge des brumes à droite de l'écran se déplace progressivement vers la gauche mais la coupure choisi par Mark Lewis est abrupte. Dans la position du moine de Caspar David Friedrich regardant la mer, notre méditation sur la nature est brutalement interrompue par Lewis, comme si la durée extraordinairement précise de 2'42" répondait d'un impératif supérieur et mystérieux.

television broadcasts (cf. his *A Sense of the End*), or his own interpretation of a film (cf. his 2000 version of Michael Powell's *Peeping Tom*). Reverting to our psychoanalytic metaphor, we could say he repeats the modern neurosis but that this repetition lends itself to displacement, to the expulsion of the object from its context as entertainment to one where it serves as art.

Lewis refutes the movie theater topos, as inherited from the grand stage venues of times past. When the art scene began welcoming what Umberto Eco termed "open works" – whereby the addressee becomes an active element for bringing a work to completion – the theater venue seemed overbearing and outmoded and thus open to challenge. Lemaître's *Syncinéma* (1951) posited an enlarged venue (the theater itself but also the audience and their live reactions) as a basic condition for revolutionary preachings on behalf of developing a "paradisical" society. Belonging to the expanded cinema[3] movement born during the '60s, filmmakers such as Jordan Belson and Stan Vanderbeek dared dream of overall utopian architectural structures where the viewing area would become an actual venue awakening superior consciousness. Contemporary art now welcomes the cinema to its own allotted spaces, such as museum and gallery venues, with the "black box" and "white cube" representing the positives and negatives of spaces where viewers stroll rather than sit. Films are no longer expected to unreel from start to finish, linking them to a narrative thread that – as the French film theorist Christian Metz points out – represents the defining aspect distinguishing them phenomenologically from the real world.

Today we have continuous cinema, cinema unlimited in time. Only fiction films remain subjected to a standard 90- or 100-minute limit, while other categories allow themselves the time they need. Films in the structuralist mode have somewhat accustomed us to film time that lasts as long as it takes for a process to get underway. In this spirit, *Algonquin Park, September* (2001) gets cut off without a proper outcome: the small craft emerging from the fog to the right of the screen is tracked in slow motion as it travels to the left before being brought to an abrupt stop by Lewis. Our vantage point is like the one enjoyed by Caspar David Friedrich's monk looking out at the sea, except that Lewis brutally cuts our meditation short, as if the extraordinarily precise time lapse of 2'42" were imperiously decreed by some mysterious and higher power.

Two Impossible Films, 1995-97, anamorphic prints

3. Coined by Gene Youngblood in his book *Expanded Cinema*, New York: E.P. Dutton & Co., 1970.

3. Gene Youngblood, *Expanded Cinema*, New York; E.P. Dutton & Co., 1970.

Mark Lewis a pris comme prétexte de *Two Impossible Films* (1995-97) deux projets mythiques de l'histoire du cinéma, qui n'ont jamais vu le jour. Le premier est une proposition de Samuel Goldwyn à Sigmund Freud, le second un projet de Sergei M. Eisenstein d'adapter à l'écran *Le Capital* de Karl Marx. Réunissant sous un même projet Marx et Freud, Lewis se livre à des effets d'annonces. Autour d'un noyau d'une fiction réduite à quatre titres : Story Development, Dramatic Conflict, Temporary Resolution, Fade Up from Black, nous verrons l'habillage des films hollywoodiens que sont les prologues et les épilogues. Lewis pastiche le vocabulaire de ces prologues : la mise en place de l'intrigue, entrecoupée des génériques, les effets répétitifs du thème musical du violoncelle dans le premier, les attaques orchestrales qui viennent renforcer l'effet de suspense dans le second sont parmi les recettes utilisées et reproduites par Lewis « à l'identique » : c'est ce qu'il définit comme un « cinéma en pièces ». La psychanalyse, sujet supposé du premier film, est abordé, la caméra cadrant un bout de square de Vancouver filmé « au raz des pâquerettes », montrant un lieu tout au long d'une journée, du matin très tôt à la nuit tombée. Lewis évoque sur le mode des films consacrés aux villes des années 20 (Vertov) le projet d'Eisenstein, qui devait aborder les thèmes de la dialectique historique au travers d'enchaînements de thèmes par associations intellectuelles et/ou sensorielles du monologue intérieur inspiré par Joyce, au cours du déroulement d'une journée très banale d'un homme (qui aurait pu être Leopold Bloom). Les références scatologiques et érotiques fusent ; le lieu est en effet investi par les chiens domestiques qui viennent assouvir là leurs besoins naturels ; les passants y mettent le pied, poussent un « shit » qui suspend le thème musical. Les génériques de Lewis rappellent par leur grandiloquence ceux d'Antoni Muntadas pour *Credits* (1984), mais là encore, ils sont les pastiches de figures stylistiques du cinéma hollywoodien.

Au milieu des années 50, une ligne de fracture, pas toujours facile à délimiter d'ailleurs, existait entre un courant « pop » et un courant « néo dada » : aux pastiches glamour d'un Jack Smith ressuscitant Maria Montez façon queer, répondaient les collages satiriques d'un Preston ou d'un Hamilton. Au regard du travail de Mark Lewis, dans une perspective contemporaine où l'on placerait Keith Sanborn, Craig Baldwin ou Antoni Muntadas, semble réapparaître une même dichotomie.

For *Two Impossible Films* (1995-97), Lewis resorted to two of the film industry's legendary projects – namely Samuel Goldwyn's attempt to get Sigmund Freud to write a screenplay, and Sergei M. Eisenstein's plan to make a feature-length film version of Karl Marx's *Das Kapital*. Weaving Marx and Freud together around a core story divided up under four headings – Story Development, Dramatic Conflict, Temporary Resolution, Fade Up from Black – he tackles the Hollywood presentation effects found in the typical opening and closing frames. He parodies the language of the film prologue, appropriating and replicating "identically" the manner in which the plot is set up, how the opening scenes are interspersed with the credits, and the repetitive effects of the theme music (cello music for the first of the two films, and repeated orchestral attacks underscoring the suspense of the second). His approach is an investigation of what he calls the "parts" of filmmaking.

Psychoanalysis, presumably the subject of the first film, is presented by framing a ground-level shot of one end of Vancouver Square, with this scene lasting from early morning to nightfall. For the Eisenstein project, Lewis adopted the film style used in movies of the '20s showing different cities (cf. the pioneering Russian documentary filmmaker Dziga Vertov). The original project was to address themes belonging to historic dialectics, whereby certain intellectual and/or sensorial associations born of an interior monologue inspired by Joyce are linked to form a sequence marking an ordinary day in the life of a man (who might well have been the Leopold Bloom of *Ulysses*). In Lewis's version, there is no lack of scatological or erotic allusions: The film site is actually besieged by dogs who come there to do their business, into which passers-by unfailingly step, each time eliciting a "Shit!" that breaks off the theme music. In their grandiloquence, the credits recall those showcased in Antoni Muntadas' 1984 videotape and installation *Credits*, but here again, they serve to parody Hollywood motion picture stylistic devices.

During the mid-fifties, an admittedly rather fuzzy split line existed between the Pop and Neo-Dada trends. Thus Jack Smith's queer-vein revival of Maria Montez in parody of Hollywoodian '30s and '40s glamor was paralleled by the satirical collages of Great Britain's leading Pop artist Richard Hamilton and the disjointed assemblages of the American filmmaker Preston Sturges. The same dichotomy seems to crop up again if Lewis's approach is seen in a contemporary context encompassing the work of Keith Sanborn, Craig Baldwin and Antoni Muntadas.

Two Impossible Films, 1995-97, anamorphic print

Translated from the French by Margie Mounier

Invention and Reinvention in the Films of Mark Lewis (The Set Theory)

Shepherd Steiner

Pages 12, 13

Children's Games, Heygate
Estate, 2002
Cornerhouse, Manchester

Page 14

North Circular, 2000
Tenement Yard, Heygate
Estate, 2002
argos, Brussels

There are many entrances to the work of Mark Lewis, but by far the best entrance one can make is via the 'set' itself. I do not refer to an on-set-Hollywood-insider information here, though I should admit at the outset to having featured in the role of the intellectual beggar in Lewis's *Two Impossible Films* (1995-1997). No, by saying the best entrance to Lewis's work is via the set, I direct one's attention to a question unique to cinematic language and as much to a law of language *tout court*. I call attention to the fact that Lewis's works from 1995 to 2002 have increasingly become set pieces, and wish to acknowledge from the word go, Gilles Deleuze's influential work on the "movement-image", its relation to the 'set', the set's difficult adequation to the frame, to cinema as a closed system and finally to the 'dividual' status of the cinematographic image.[1]

Fearful as I am of getting lost in terminology, however, let us stick to a close reading of the works themselves, and simply begin in the knowledge that Lewis's work as a whole can be divided into a set of practices that devolve upon the inventions of cinema on the one hand, and its reinvention on the other hand. This division of Lewis's corpus into a set of concerns has a specific heuristic function. Not only does it roughly differentiate his works from the period 1995 – 2000 from those works produced between 2000 – 2002, but a description of the more exclusively cinematic works from the first stage of Lewis's practice ably introduces the audience to the painterly questions raised in works from the second stage of his practice. Such a vantage point is a necessity if one is to glimpse the fugitive status of the cinematographic image: a category that can only be staged as an operational link between the two imperatives of the set.

On the subject of *heúrêka!*

The first stage of Lewis's project is most easily grasped as an attempt to categorize, conceptualize, or think the largeness of cinema.[2] Little wonder Lewis has described his practice in terms of what he calls the "part cinema." Like the photographic work of fellow Canadian Jeff Wall, Lewis's "part cinema" breaks down the ungraspable enormity of the cinematic apparatus into parts. One should note here the ideological imperative, for the "part cinema" is very much akin to ideology critique. The General is distilled out

1. See especially , "The first level: frame, set or closed system", in Gilles Deleuze, trans. H. Tomlinson, *Cinema 1: The Movement Image*, (London: Athlone Press, 1992), pp. 12-18.

2. See "Mark Lewis in Conversation with Jeff Wall", in *Transcripts*, Vol. 03, Issue 03, pp. 167-197.

15

on the level of the Especial, the largeness of the cinematic apparatus is reduced down to bite-sized pieces: smallness being the size best suited for critical consumption![3]

The "part cinema" is an epistemological project. Its aim is to isolate what cinema had invented for itself. By saying what cinema had invented for itself I mean to pinpoint Lewis's interest in isolating certain key conventions or tropes of representation that the cinematic apparatus had to invent in order to come into being in the first place. Lewis describes "these uniquely cinematic moments, (as) moments created by needs generated within the form itself."[4] Given the symbolic language put in action here – and also as a way of acknowledging its anthropomorphic slant on things – one could say that the "part cinema" focuses on those moments when cinema is most alive and also most hackneyed.

This said, characterizing the "part cinema" as the first of two stages in Lewis's practice should in no way lead one to minimize its significance. One must be careful not to characterize it as juvenilia, for focussing on what cinema had invented for itself speaks to that broad set of ontological concerns that make present, or insure cinema's presence in the world. No small task, especially given the hegemony of the cinematic form in culture at large. In any case, the "part cinema" is concerned with the barest or most primordial conventions of cinema – those parts of cinematic language that secure the reception and insure the consumption of cinema, as cinema.

Take *Two Impossible Films*. Lewis's first cinematic feature. This set of two unrealized films is centered on what can only be described as an exemplary moment of cinematic invention: the title sequence. Somewhat like, but by no means identical to the frontispiece of a book, the title sequence makes of the raw or edited narrative a cinematic object; it prepares the ground for every cinematic reading or entrance by naturalizing the exchange relations upon which any entrance to, or reading of cinema, depends. Working much in the mode of a literary critic, Lewis works as a critic of cinematography. Gérard Genette's literary semiology is a good parallel to Lewis's interests in this regard.[5] Like Genette's focus on grammatical structures, Lewis's practice is driven by a formal imperative to reduce the cinematic medium down to a set of linguistic formulae for production and reception. What's more, one notes a similar field of interests ranging from explicitly paratextual questions – questions outside textual narrative, like those relating to the cinema's

3. Suffice it to say that largeness and smallness form an important set in Lewis's work, and that in the second stage of his work the antinomy largeness/smallness undergoes an important development, which we will return to in a moment.
In his famous passage contrasting allegory and symbol Coleridge writes: "... a symbol is characterized by a translucence of the Special in the Individual or of the General in the Especial or of the Universal in the General. Above all by the translucence of the Eternal through and in the Temporal. It always partakes of the Reality which it renders intelligible;
and while it enunciates the whole, abides itself as a living part of that Unity, of which it is the representative."
Samuel Taylor Coleridge, "The Statesman's Manual", *The Collected Works of Samuel Taylor Coleridge*, vol. 6:
Lay Sermons, (Princeton: Princeton University Press, 1972), p. 30.

4. Interview with Mark Lewis by Jérôme Sans, "Trying not to make films that are too long",
in *Mark Lewis Films 1995-2000*, (London: Film and Video Umbrella, 2000), p. 48.

5. That one's ability to read or enter a film at all hinges on the disparate set of conventions that mediate between the different infinities of the cinematic work and the reader. See Gerard Genette, *Paratexts: Thresholds of Interpretation*, trans. J. E. Lewin, (Cambridge: Cambridge University Press, 1997).

16

architecture of consumption – to a number of intratextual conventions that both hinge upon and drive narrative.

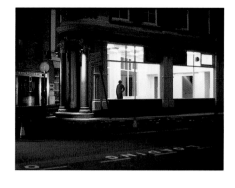

Smithfield, 2000, production still

The "part cinema" is dominated by the intratextual questions of figural language. For example, there is the necessary resolution or ending as in *A Sense of the End* (1996); the way this can be enhanced by a musical score, achieved through a character's departure, death, or quiet time spent in a car, and how even the many divergent story lines of a plot can be contained by the geographical locus of a city. There is the quintessential "after shot" as in *After (Made for TV)* (1999), as well as the spare use of sequential montage and the 9 frame fast cut to propel narrative as in *Peeping Tom*, 2000. But one would also have to include questions of narrative curiosity and intensity achieved through camera work alone. Thus the documentary feel of the initial establishing shot soon broken by the breathless flight toward detail in *North Circular* (2000), the prowling eye of *Smithfield* (2000), or the very painterly establishing shot of *Tenement Yard, Heygate Estate* (2002), where the onus for prowling is more explicitly shifted onto the viewer smothered by a monolithic setting and appreciative of any detail whatsoever.

And who can forget the voyeuristic tracking shot of *Jay's Garden, Malibu* (2001), so intensely desirous for the next scene of titillation that it seems unable to cement a long-term relation with any of the objects on hand. The relatively banal equivalent of this in *Children's Games* (2002), where the cinematic *flaneur* may wish to isolate various genre scenes in passing. From the elevation of one's carriage such *tableau* on the margin are quite pleasing! No less important, are the 4 minutes of *The Pitch* (1998), *Wind Farm* (2001) and *Algonquin Park, Early March* (2002). Lewis ascribes the length of these works to the material constraints of the single 35mm film reel and its tremendous cost.

Already with *Smithfield, North Circular* and the like we have arrived at the second stage of Lewis's project. The one dimensional reading we have offered up until now falls hopelessly short of the palimpsest-like layering upon which these newer works are built. What Stephen Bode has called the "building blocks" of cinematic invention begin to play piggy-back with the possibility of reinvention. More succinctly, one begins to see (within the divisible set of practices making up Lewis's corpus of works from 1995 – 2002) an increasing emphasis on one particular set of material constraints which bear directly on cinema's reinvention as painting. I refer to the single short take, usually silent and of 4 minutes in length but ranging from the longish 2 minutes and 37 seconds of *Algonquin Park, September* to the shortish 7 minutes and 41 seconds of *Children's Games, Heygate Estate*, and inclusive of a work like *Wind Farm* with its lazy, easily habituated sound. With the exception of *Jay's Garden, Malibu* all are single, unedited shots. It is as if in Lewis's concerted attempts to grasp cinema's seductive power over us, what has slowly dawned on him is that the crux of the matter is zeroing in upon the singularly impossible question of the "pituresque" image. It is a point at which largeness creeps back into Lewis's cinema of small parts by default, when set theory opens onto infinity.

17

Algonquin Park, Early March,
2002,
location photo

Algonquin Park, Early March,
2002,
location photo

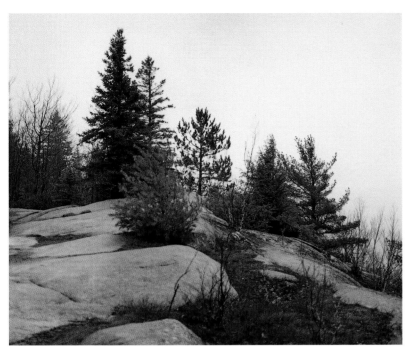

Algonquin Park, September,
2001,
location photo

Algonquin Park, Early March,
2002,
location photo

19

Algonquin Park, Early March, 2002,
location photo

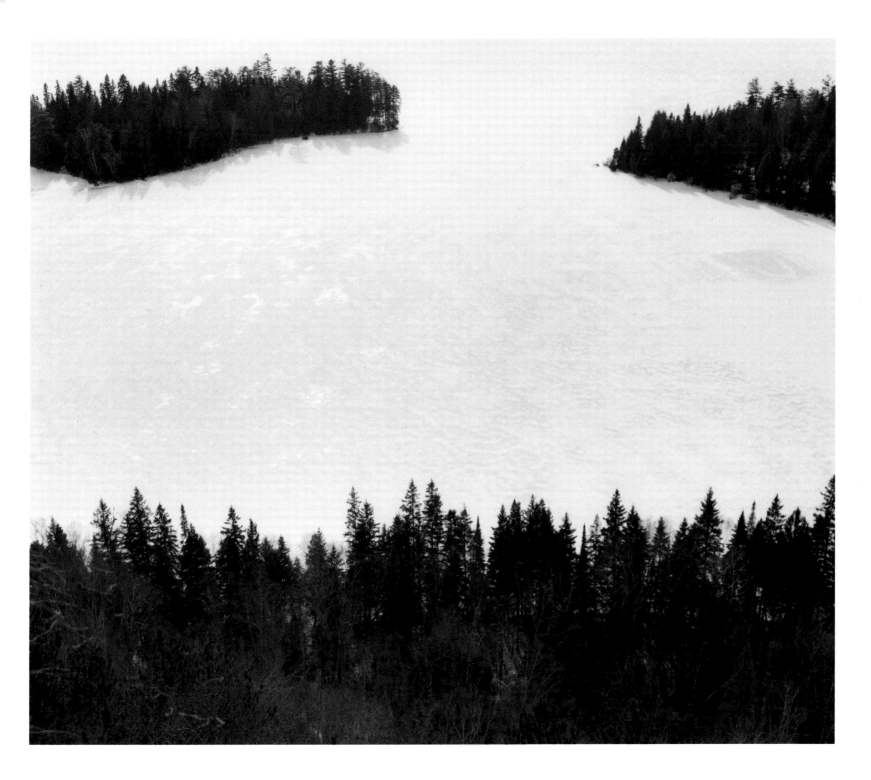

It is a strange moment in this body of work, a kind of awakening to the semi-automatic and hence utterly counter-intuitive nature of invention in cinematic language. For if an increasing concern for the "pituresque" is precisely what differentiates the aesthetic from the epistemological aspect of this project, the question of the "pituresque" is also that which most perfectly distils the categorical imperative of the latter stage. What the "part cinema" finally tells us is that the imagination required for invention is almost wholly possessed by the inhuman and unthinking medium that is cinema.[6] As the assumed zero-point of cinematic language – the "part cinema" distilled to its essence – the usually silent, single, unedited shot whisks us back to that originary moment of cinema when in the hands of the Lumière Brothers cinematography itself first shouted out *Eureka!* by any other name.

(eureka!)[2]

The convergence of Lewis's work around this originary moment of cinematic eureka suggests not only that it underwrites the presencing capacity of the medium more than any other single linguistic convention, but that in so doing it (re)presents a history no longer circumscribed to the cinema alone. The short, silent, single shot reaches much further. Like the paradigmatic moment of cinematic invention precipitated by the Lumière's *A Boat Leaving the Harbour* (c. 1896), the threshold experience at issue translates a spectrum of alien figures, conventions and tropes on the spot, for the first time and in a makeshift manner to suit the needs of its closed system. The example of Lewis's two latest set pieces *Algonquin Park* and *Heygate Estate* are especially relevant here. Working within the parameters of a broadly inherited tradition of language both sets reach back to a dim beginning that clearly links cinematography to the language of painting[7]: the former to the poetics of the symbolists and the Northern Romantic tradition, the latter to the far more prosaic tradition of realism and its roots in Northern Renaissance painting.

The "pituresque" moment with which we are concerned is a hypertrophic instancing of the "part cinema" as a whole: it stretches the lineaments of the single shot to its breaking point by pushing the durational image to a near static conclusion. So if the "part cinema" was a project to extend the life of cinema after its supposed death, zeroing in on the short take returns to the supposed moment when cinema was most alive in order to reinvent the mainspring of its possibility.

The key question in both filmic sets – indeed in each piece from each set – is how to make a durational work that has all the strikingness or instantaneous impact of the image, given that the temporal horizon of durational art militates against the instant and its strikingness.[8]

6. So much for the theory that cinematic invention hinges entirely on the contribution of individuals!
Put away those books in which you read endlessly about the early and very special magic of the Lumière Brothers, the auteur director or Godardian genius, and the ingenuity and vision of the renegade director – say a Hitchcock or a Peckinpah – enfranchised by the studio system.

7. Photography is not at stake here, but rather painting.

8. In this sense, Lewis's new work addresses cinema's lack of place in the traditional setting for high art, for what Jeff Wall refers to as "the highest art in the highest places" makes no room for the cinematic experience.

The paradox here is clear enough, for even if *Algonquin Park, September* and *Tenement Yard, Heygate Estate* are pendants to works with a far more cinematic – that is visually dynamic – legacy, in no way does this secure the presence of the "pituresque" image in either case. Furthermore, if at first glance either stands as convincing evidence for the return of the painterly image, it is worth remembering that the internal dynamic of each only promises the image as a memorial reference. Certainly what Michael Fried would call the *coups de théâtre* of *Algonquin Park, Early March* and *Children's Games, Heygate Estate* can in the end only be "judged... shallow and fleeting at best", but if anything this should spark a corresponding inquiry into the sincerity of the picture-likeness of *Algonquin Park, September* and *Tenement Yard, Heygate Estate* as well.[9] After all, is not the pathos invoked by the placement of children amidst the inhumanity of tower blocks as equally theatrical as a dolly shot that feels like an amusement park ride? And when it really comes down to the formal questions of the *Algonquin Park* set, is the remarkable sequence of "revelations", "reversals" of perspective, and "turns of plot" achieved through the shifting focal length of the zoom and its incumbent decompression of the image into a winter scene by Breugel, any more dangerously closer to kitsch than a still shot of a boat on a lake with mist swirling round? Lewis has admitted that the original 4 minute take was too long and had to be cut down to 2 minutes and 37 seconds: presumably the delicate allusion to Friedrich and Böcklin would otherwise sink in a plainly sentimental image of Canadiana.

How (eureka!)[2] distinguishes itself from eureka and how the former actually operates on the grammatical level is crucial to all of this. The traditional distinction in rhetoric between *inventio* and *dispositio* can help, but what I am especially interested in is the way invention is set in tension with disposition. (In spite of the proximity of the two works in each set to one another, for instance, I am not arguing that the second stage of Lewis's practice is simply the supplanting of invention by disposition.) What Lewis comes upon or discovers at this moment of invention to the second power, is that cinematic eureka hinges on nothing less than the very conventional disposition, arrangement, or ordering of syntax. To couch this anxious dialectic in yet another frame, one could say Lewis realizes that the seduction of the image is always underwritten by the persuasiveness of cinematic narrative. Following Paul de Man we can simplify matters still further and say that metaphor as the 'paradigmatic figure' of the aesthetic leans heaviest on the always slippery 'rhetorical model of the trope', in the case of Lewis's work, metonymy and synecdoche.[10]

9. Michael Fried, *Absorption and Theatricality: Painting and the Beholder in the Age of Diderot*, (Berkeley: University of California Press, 1980), p. 78.

10. See de Man, "Semiology and Rhetoric", and "Reading (Proust)", in *Allegories of Reading: Figural Language in Rousseau, Nietzsche, Rilke, and Proust*, (New Haven: Yale University Press, 1979), pp. 3-19, 57-76.

Algonquin Park, September, 2001,
production still

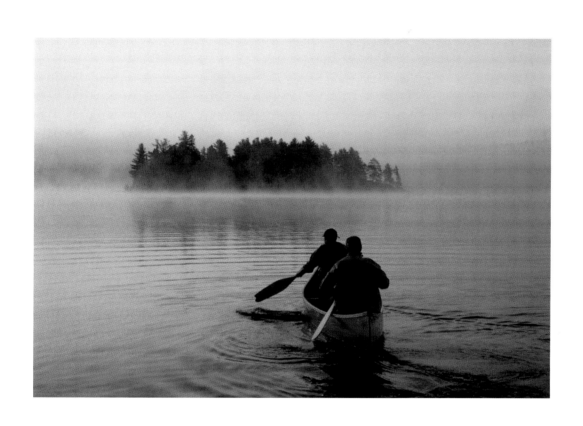

Algonquin Park, September, 2001, video,
Liverpool Biennial, Tate Liverpool

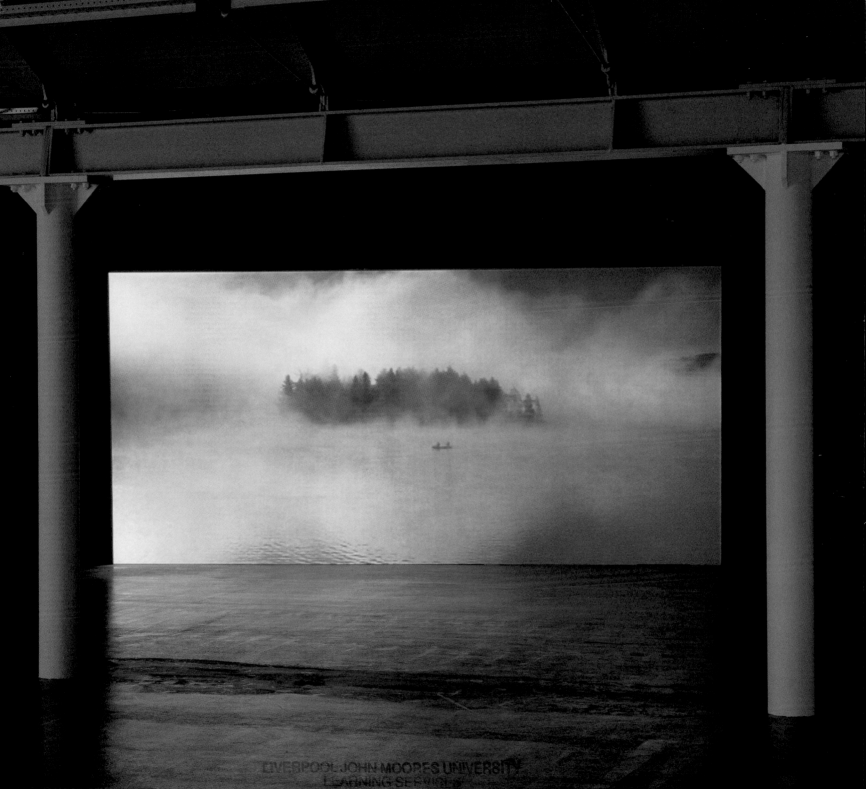

The slow zoom out in *Algonquin Park, Early March* is the best example to my mind. Metaphor, a paradigmatic structure that accomplishes the complete substitution of one thing for another, relies upon metonymy, a syntagmatic structure that sustains and supports it through the infrastructural framing or setting of the cinematic text. Thus the ever-expanding frame of analogy can skip from the likes of a Malevich or Ryman 'white on white', even a Barnett Newman 'white out', to the picturesque silhouettes of the Group of Seven, a b&w motif imported directly from abstract expressionism, and finally, a winter scene straight out of Breugel. For all intents and purposes the image faces one in the here and now without actually being there at all. There in all its thickness and immediacy precisely perhaps because of its absence. How the painterly image can be period, when it is a cinematic image we are looking at, haunts this work. In *Algonquin Park, Early March* metonymy goes head to head with metaphor, and it is impossible to decide which one is inventing the other, which is original and which derivative. Given such indeterminacy one can rightly read the work from either the metonymic or metaphoric perspective, for both cinema and painting are no doubt present and accounted for. What the work makes a play for, however, are considerably higher stakes.

The zero point of cinema

What exactly these stakes are is hard to define. Certainly the so-called "monochrome effect" is part of an answer: more than anything else it legitimates and sets off the play of substitutions and associations upon which works like *Algonquin Park, Early March* and *Algonquin Park, September* depend. But just as certainly the strained relationship between painting and cinema is part of an answer as well. Both *Algonquin Park, Early March* and *Algonquin Park, September* ably speak to the lack of contact between cinema and its other, painting. How can we reconcile this difficult problem of identity and difference?

The Pitch, which also hinges on a 4 minute zoom, might provide a tentative answer. In fact, *Algonquin Park, Early March* is a remake of *The Pitch*, and because it addresses inadequacies in the earlier work, comparison holds out the promise of a reading of Lewis's new work that does not fall victim to the reconciliation of dialectics, but rather posits a non-dialectizable zero point of cinema. It is slippery terrain that we now set out on: so slippery in fact that the likes of a classical trope such as metonymy which works through association, can anamorphically transform before our very eyes into a figure such as synecdoche where a part can stand in for the whole.

Charles Esche who writes very well on *The Pitch*, describes it "as a proposal, which quite beautifully completes itself in the making. The slow zooming out of the camera from the original focus on the speaker to the final image of him alone in a crowd of expectant travellers/extras, is the fulfilment of the idea of the work. There is an extraordinary cohesion between form and content, reflecting, in Lewis' most narrative work, the overriding significance of the formal and the visual in his production, as well

as confounding the earnestness of his pitch in the first place."[11] In Esche's reading a recourse to the language of the symbol and its hoped for coincidence between form and content denies the allegorical aspect of *The Pitch*, to which the narrative alludes, of which "the pitch" persuades, its presentation on a monitor suggests and the epistemological aspect of the "part cinema" makes reference. What the responsible viewer should recognize besides these perhaps misleading references to another whole (or as yet unrealized film) is that the coherence between form and content is at least as misleading and in as unstable a relationship. Who knows whether to read this work literally as an attempt to garner favour and investors for a film project about extras, or figuratively as the thing in itself?

The Pitch is a transitional piece, a work that attempts to ironize the synecdochal relation upon which the "part cinema" is based. One confronts a very different synecdochal imperative in *Algonquin Park, Early March*. It too links the part to a whole, but this part – by virtue of the complications set in motion by the tropological structure of metonymy and metaphor – orbits a whole that instead devolves upon the work itself. For just as whiteness is placed in proximity to trees and thus associated with sky, this juxtaposition put in contact with skaters to make snow, this put next to a far shore and made lake, this set in a winter landscape to build a world, the premature ending cuts short the possibility that painting will ever settle for being anything like 'one' in any such series of scenographic successions. Rather, painting only has its hope set upon occupying a kind of zero point within cinema and more precisely heterogeneous to the cinematic work at hand.

If the camera work of *The Pitch* privileges the integrity of form and content, something in turn ironized by the language of persuasion, etc., *Algonquin Park, Early March* sets up or priorizes the "pituresque" image as a substitutive string of metaphoric wholes by using a grammar of persuasion. The difference is huge, for in the new work otherness is not extrinsic but rather made intrinsic to the fabric of the cinematographic experience. The whole – in all its largeness – moves to occupy a space within and beyond the cinematic face of things.

11. Charles Esche, "Mark Lewis Films 1995-2000", in *Mark Lewis Films 1995-2000*, ibid, p. 33.

Children's Games, Heygate Estate,
2002,
location photos

31

Page 33

Tenement Yard,
Heygate Estate, 2002
Children's Games,
Heygate Estate, 2002
argos, Brussels

In the case of *The Pitch* the organic metaphor of coherence is underwritten by the grammatical structure of the slow pan out itself. As de Man tells us, metonymy – which underwrites metaphoric coherence – works syntagmatically through contingency, association, or spatial proximity in a narrative order. Understanding this rhetorizing of grammar – the last great problem of formalist analysis and something which de Man accomplishes in his book *Allegories of Reading* – is difficult stuff, but it has a very real urgency on the interpretative problems and questions of seeing confronted in works like *Algonquin Park, Early March* and *The Pitch*. Watching either film it is clear that filmic grammar, more than anything else, is supplying us with the answers or tuning us into meaning – even if *The Pitch* overflows with persuasive content and *Algonquin Park, Early March* is devoid of it. Indeed, it seems obvious that the latter was made precisely to clarify this point.[12] Not simply to rid the zoom of its knowing irony, or even to emphasize that its exponential 'thinking' is about the unexpected and make-shift inventions of cinematic language and the way that language means. But to demonstrate in real time how metonymy can be catachretically forced to do the work of synecdoche and in so doing posit a zero point of cinema by selectively passing over the succession of settings provided.

Both the *Algonquin Park* and *Heygate Estate* set pieces ably speak to the heterogeneous point of contact between cinema and its other, painting. Because the "pituresque" image is an impossible horizon, or more succinctly the zero point in a numerical system of value that constitutes the cinematic enterprise, returning cinema to its painterly origin can but fail. The image is outside the closed system of cinema, but as a continuously possible 'outside' or *hors champs* condition, it is nonetheless governed by the laws of that system and recoverable for that system; inasmuch also 'inside' it.[13] Hegemony – even cinematic hegemony – can work in no other way.

12. Beyond these linguistic arguments there is also simply the feeling one has that if *The Pitch* is a more overt dialogue with persuasion, then *Algonquin Park, Early March* must be about seduction. There is something about the pacing and slowness of *Algonquin Park, Early March* that lulls or seduces one into belief – literally because what unfolds is so tenuously close to the question of the image. On the other hand, the note of desperation struck in *The Pitch* always leads one back to the fact that narration is manifest, and as such condensed, sped up, highlighted and made urgent, because the end is drawing near. Each, in fact, has a fairly distinct purchase on the fact that time is short: the latter by embedding itself in an economy where time is money, the former by staging the question of the image in terms of a prior narration, or what Heidegger calls "truth setting itself to work." See Martin Heidegger, trans. A. Hofstadter, "The Origin of the Work of Art", in *Poetry, Language, Thought,* (New York: Harper Collins, 1971), pp. 35-38.

13. Paul de Man, "Pascal's Allegory of Persuasion", in *Aesthetic Ideology,* ed. A Warminski, (Minneapolis: University of Minnesota Press, 1996), pp. 51-69.

If the referential aspect of the "part cinema" has mildly distracted Lewis's project from the word go, one can also assume with some confidence that an increasingly fuller grasp of the question of allegory – for that is ultimately what is at stake – is arrived at in his works from 2000-2002. If the title of *Two Impossible Films* is revealing of a recognition of this weakness from the very beginning, *The Pitch* is a significant attempt to ironize the condition, the likes of *Algonquin Park, Early March* and *Algonquin Park, September* stand out by dint of their deployment of the positional power of language – meaning that metaphor is openly operating by virtue of spatial contiguities and associative links within the very geography of the filmic syntax.[14]

None of this should come as any surprise either. After all, surely what strikes one first about works like *Algonquin Park, Early March* and *Algonquin Park, September* (or the majority of Lewis's work for that matter) is that their installation is carefully orchestrated to heighten one's engagement with the moving image as thing or object, rather than merely screen or narrative device. Grounded in the viewing space rather than floating or hanging above it, all of Lewis's film works stand on an equal footing with that of the spectator. With the absence of sound as well as the premature endings of both the *Algonquin Park* works included in this Spartan mix, the imperative seems to be that of undermining one's normalized relations to and expectations of both cinema and painting, in hopes of fomenting a new form of object relation with them, one more sensitive to the very strange species that is cinematic language.

In any case, the metaphysical system that allows for the aesthetic to emerge in both *Algonquin Park, September* and *Algonquin Park, Early March* is ground in the tension between metaphor and metonymy. Both works are about the aesthetic superiority of metaphor, but the claim can only be sustained by virtue of a metonymic infrastructure that depends on the positional power of language, the placement and associative matrix of a sequence of settings within a compositional or narrative order, which takes roughly 4 minutes to happen. I would point to this as one instancing of Lewis's responsibility to both the uniqueness of cinematic language and the singularity of any one particular single short take. This might translate as an interest in the miniaturization of movement within a monolithically large, static frame, but the tension between largeness and smallness animated by metaphor and metonymy ought also to have a purchase on the Kantian sublime. And in fact everything points to the conclusion that the 4 minute tracking sequence of *Algonquin Park, Early March* does trace a line between the mathematical and dynamic sublime, even if only a line traced in the snow.

14. One could say that the highest claims for "the highest art in the highest places" always devolve upon such semi-automatic grammatical patterns, in this case with the adjoiner being that in cinema this takes place as a function of syntagmatic relationships hinging upon the placement, relative proximity or positionality in which each of these referential, metaphoric or absent images exist, are materially handled, or actually experienced in a narrative.

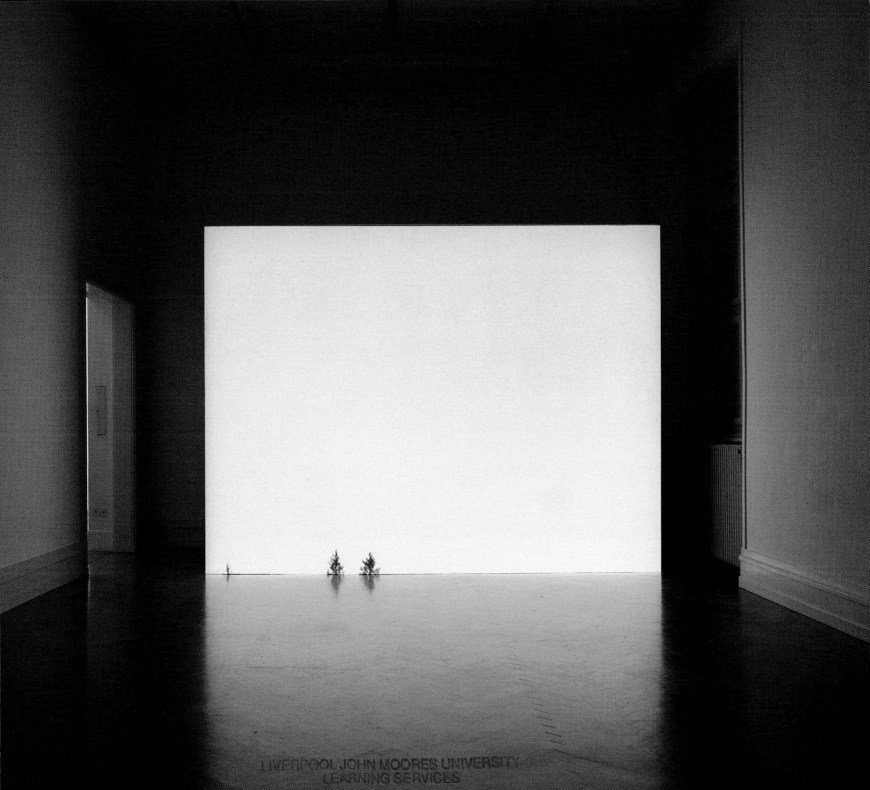

Algonquin Park, Early March,
2002, Kunsthalle Bern

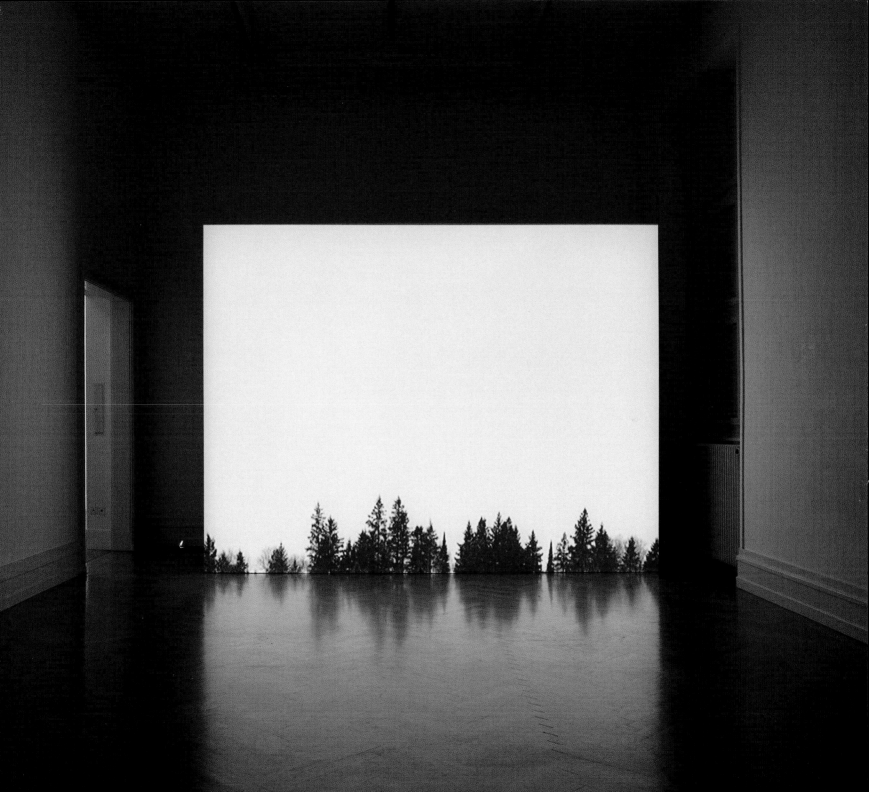

Algonquin Park, Early March,
2002, Kunsthalle Bern

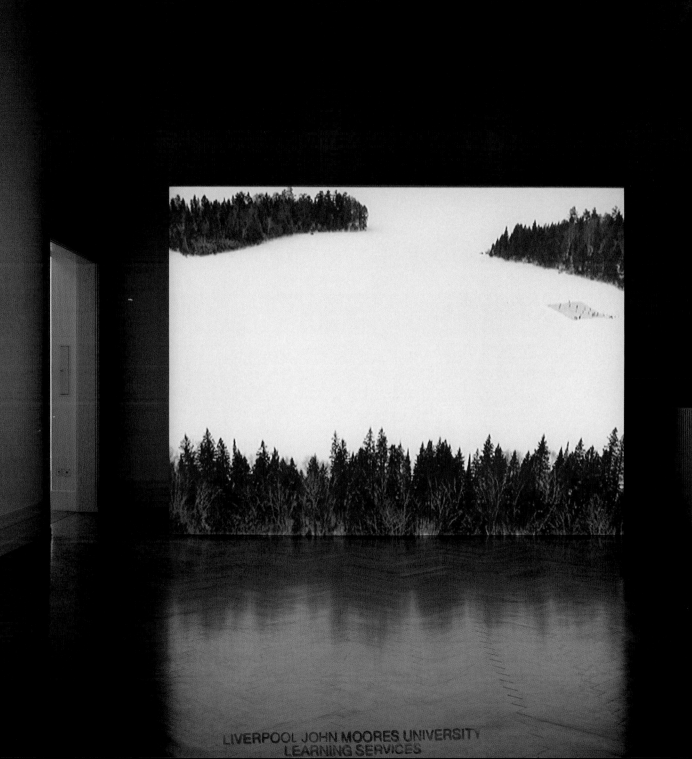

Centrale, 1999,
Kunsthalle Bern

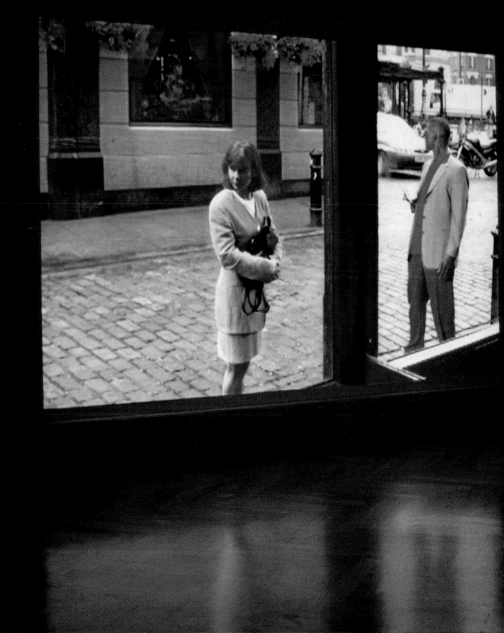

Zum Malerischen
in den neuen Filmen von Mark Lewis

Bernhard Fibicher

Mark Lewis hat 1995 begonnen, mit dem analytischen Konzept *cinema in parts* zu arbeiten und kurze Filme zu realisieren, in denen er einzelne Bestandteile des Mainstream- und Avantgarde-Kinos isolierte. Seit ein paar Jahren verlagert sich nun in seinem Werk das Gewicht vom rein filmgeschichtlichen Bezug[1] auf eine stärkere Autonomie des Mediums Film. Diese Autonomie ist allerdings relativ, da sich nunmehr eine immer intensivere Verbindung zur Malerei abzeichnet. Die neuen Filme von Mark Lewis geben nicht mehr vor, (Fragmente von) Geschichten zu sein. Sie erzählen nicht mehr, wie etwa in *Centrale* (1999), die unmögliche Begegnung zweier Menschen. Dazu sind sie oft relativ statisch und/oder bestehen aus einer einzigen, ungeschnittenen Sequenz. Ihre eminent malerische Wirkung ist einerseits dem Rückgriff auf bekannte Werke der Malerei und klassische motivgeschichtliche Elemente und Genres und andererseits der Übertragung anderer medienspezifischer Charakteristika auf den Film zu verdanken. Die Filme der „synthetischen Periode" von Mark Lewis, und ganz besonders die in Nordamerika gedrehten (ist bei Lewis Nordamerika = Natur und London = Gesellschaft?), verleiten daher zur – wie wir sehen werden, problematischen – Assoziation mit Bildern.

Jay's Garden, Malibu (2001) wirkt wie ein Gemälde von Arnold Böcklin oder Karl Blechen mit Faunen und Nymphen in mediterraner Landschaft. Diese wird durch die gleitende und einige Pflanzen streifende Kamera, die sog. Steadycam, greifbar und intim erfasst. Dadurch findet ein beinahe ironischer erotischer Transfer zwischen dem Garten und seinen Bewohner/innen statt: Es handelt sich allesamt um Pornodarsteller/innen. Die Laube mit den Glastrauben deutet auf Bacchus/Dionysos, auf Sinnlichkeit und Ausschweifen der Sinne hin. Bacchus ist aber nicht nur der Gott des Weins, sondern auch des Theaters. In *Jay's Garden, Malibu* ist alles künstlich, alles aufs Präziseste inszeniert: von der Natur – es handelt sich um den Privatgarten des amerikanischen Landschaftsarchitekten Jay Griffith – bis zu den korrigierten Körpern der Schauspieler/innen. Allein, zu zweit, in kleinen Grüppchen huschen diese Satyrn und

Painterly Aspects in Mark Lewis's New Films

Mark Lewis began to work with the analytical concept of "cinema in parts" in 1995 and realized short films that isolate particular elements of mainstream and avant-garde cinema. For the past few years, his focus has shifted away from its purely film-historical reference[1] and towards film's greater autonomy as a medium. It is a qualified autonomy, however, since Lewis's work displays an ever closer relationship to painting. In contrast to *Centrale* (1999), which narrated the impossible encounter of two people, his new films no longer pretend to be (fragments of) stories. Moreover, they are often relatively static and/or consist of a single, uncut sequence. Their eminently painterly effect is due both to a recourse to familiar paintings, classical motifs and genres, and to the transfer to film of other media-specific characteristics. The films in Mark Lewis's more inclusive "synthetic period", particularly those produced in North America (does Lewis equate North America with nature, and London with society/culture?), therefore draw the viewer into an association with painted images – a problematic association, as we shall see.

Jay's Garden, Malibu (2001) has the effect of a painting by Arnold Böcklin or Karl Blechen, with fauns and nymphs in a Mediterranean setting made tangible and intimately captured by the camera, a so-called steadycam, gliding through and brushing against some plants. The result is an almost ironic erotic transfer between the garden and its inhabitants, who, without exception, are all actors and actresses from pornographic films. The bower with its glass grapes alludes to Bacchus/Dionysos, to sensuality and debauchery. Bacchus, however, is not only the god of wine but also of the dramatic arts. In *Jay's Garden, Malibu* everything is artificial and staged, down to the most minor detail, starting with nature – this is the garden of Jay Griffith, the American landscape architect – and ending

1. For more on this, see Jean-Michel Bouhours' contribution to this publication and *Mark Lewis. Films 1995-2000*, ed. Film and Video Umbrella, London, 2000.

1. Siehe dazu den Beitrag von Jean-Michel Bouhours in vorliegender Publikation sowie *Mark Lewis. Films 1995-2000*, hrsg. von Film and Video Umbrella, London, 2000.

43

Nymphen durch die kalifornische Landschaft, tauchen unvermittelt bei einer Wegkrümmung auf, setzen zu einer heiteren Verfolgungsjagd an, verschwinden wieder hinter dem Gebüsch. Der Film ist eine moderne Idylle. Die klassische idyllische Dichtung führte eine künstliche „natürliche" Welt mit schwebendem Realitätscharakter vor. Die Aktion darin bestand hauptsächlich aus erotischen Szenerien. Auch die Motive der Kahnfahrt und das Auftauchen der Wunschlandschaft Insel sind bekannte idyllische Motive. Bei Mark Lewis nehmen sie allerdings epische Dimensionen an.

Die beiden Filme *Algonquin Park, Early March* und *Algonquin Park, September* vereinen die verschiedensten malerischen Einflüsse. Vordergründig erinnern sie an die nordamerikanische Tradition der sublimen Landschaftsmalerei im 19. Jahrhundert, etwa der Hudson River School. *Algonquin Park, Early March* (2002) besteht aus einem langsamen, schier endlosen Rückwärtszoom, der aus einer weissen, monochromen Fläche sich entwickelnd, erst am Schluss den Ort, das Sujet und den Standpunkt des Betrachters freigibt. Die vom Schnee befreite rautenförmige Fläche, deren Spitze den rechten Bildrand berührt, scheint Pieter Bruegels d.Ä. Gemälde *Jäger im Schnee* (1565, Kunsthistorisches Museum Wien) entlehnt zu sein. Das Eisfeld in der Ferne, auf dem sich Kinder, Tiere und Erwachsene tummeln, ist in beiden Fällen ein Zeichen menschlich-unbekümmerter Einordnung in die Unermesslichkeit und Unerbittlichkeit der Natur. Bruegels Winterlandschaft gehört in eine Folge von Darstellungen der Jahreszeiten – auch bei Lewis scheint die Zeitangabe in den Titeln auf die saisonale Ausweitung des Konzeptes hinzuweisen. Bei Bruegel kontrastieren die auf dem blanken Rechteck Schlittschuh Laufenden mit der buckligen Gruppe der erfolglos heimkehrenden Jäger und der die Köpfe hängen lassenden Hunde. Der Maler will uns mit den Jägern identifizieren, denen wir in ihrem diagonalen Gang durch das Bild folgen: Er will uns ins Bild und in seine „Geschichte" hineinziehen. Wie die Jägergruppe nimmt auch die Kamera bei Lewis einen erhöhten Standort ein – einen völlig emotionslosen allerdings. Lewis' Rückwärtsbewegung bringt Distanz zwischen die Landschaft und den Betrachter. Sie führt zu keiner Offenbarung, sondern geradlinig und kühl bis zur bestmöglichen minimalen Kadrierung. Der regelmässigen Öffnung des Zooms entspricht umgekehrt die allmähliche Schliessung des Bildfeldes. Auch wenn Bruegels Winterlandschaft in *Algonquin Park, Early March* deutlich mitklingt, so ist die kurze Sequenz von Mark Lewis kein Bild, sondern deutet einen der möglichen Wege zu

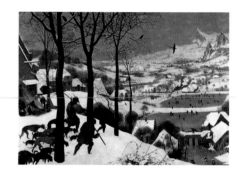

Pieter Bruegel d.Ä., *Jäger im Schnee / Hunters in the snow*, 1565

with the actors' and actresses' sculpted bodies. These fauns and nymphs – alone, in pairs, or in small groups – flit across the Californian scenery, suddenly appearing at a bend in the footpath, or setting out on a playful chase, and vanishing again into the shrubbery. The film is a modern idyll. An artificially "natural" world is also presented in classical bucolic poetry, with reality taking on an uncertain character; its "action" consisting mainly in erotic scenes. The motifs of the boat-ride and the appearance of the ideal landscape feature of the island are further bucolic topoi. In Mark Lewis's work, however, they have acquired epic dimensions.

Algonquin Park, Early March and *Algonquin Park, September* are two films that unite extremely disparate painterly influences. At first sight, they are reminiscent of the North-American tradition of sublime 19th century landscape painting, i.e. the Hudson River School. *Algonquin Park, Early March* (2002) consists of a slow, almost endless zoom-out, which starts with a monochrome white surface and only at the end reveals the location, the subject and the viewer's stand-point. The lozenge-shaped surface cleared of snow, with one corner touching the right edge of the image, seems to be inspired by Pieter Brueghel the Elder's painting, *Hunters in the Snow* (1565, Kunsthistorisches Museum Vienna). In either case, the distant ice-field with frolicking children, animals and grown-ups is a symbol of man's resilience and unconcern about his vast and merciless natural environment. Brueghel's wintry landscape is part of a series of paintings of the seasons – Lewis's reference to time also indicates a seasonal aspect to his concept. In Brueghel the skaters on the polished lozenge contrast with the hump-backed group of unsuccessful hunters and dejected hounds. The painter wants us to identify with the hunters by bringing us into their diagonal journey across the painting – he wants to draw us into the painting, into his "story". Lewis's camera adopts an elevated point of view, similar to that of Brueghel's hunters, but one that is completely devoid of emotion. His reverse angle distances the viewer from the scenery. Not leading to a revelation, the camera draws a cool, straight line to the optimal, minimal frame. The gradual, regular opening of the zoom is in

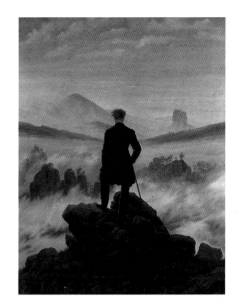

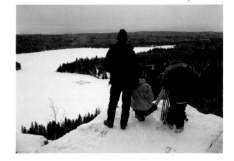

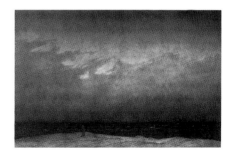

Caspar David Friedrich,
Der Wanderer über dem Nebelmeer / Wanderer Looking over the Sea of Fog, ca. 1818

Algonquin Park, Early March, 2002, production still

Caspar David Friedrich,
Der Mönch am Meer / The Monk by the Sea, 1809-10

einem Bild an, will sagen: Der Film ist ein potentielles Bild. Die erste Minute der Märzversion von *Algonquin Park* weist schon deutlich auf den Unterschied zwischen den beiden Medien (Film und Malerei) hin. Die schimmernde weisse Fläche tritt nicht als monochromes Bild auf, sondern als reine Lichtprojektion – oder gar als eine Störung? Wie man sie auch interpretiert, sie suggeriert ein *fehlendes* Bild. Dazu nimmt die in den Raum gestellte Wand ganz offensichtlich nicht die Rolle eines Bildträgers, sondern eines Bildempfängers ein.

Ein weiteres bekanntes Gemälde dient *Algonquin Park, Early March* gleichzeitig als Vor-Bild und als Mittel, über das Bild hinauszugehen: Caspar David Friedrichs *Der Wanderer über dem Nebelmeer* (um 1818, Kunsthalle Hamburg). Dass Lewis dieses Werk eingehend studiert hat, beweist ein *production still*, auf dem man den kanadischen Künstler von hinten, auf einem schneebedeckten Felsvorsprung stehend, über den See zu seinen Füssen blicken sieht. Wie Friedrichs Wanderer bildet er eine dunkle Silhouette im Zentrum der Komposition; sein Kopf tangiert die oberste Horizontlinie. Beide Rückenfiguren stehen gleichzeitig über und in der Landschaft, die sich ihnen – hier durch den Nebel, dort durch die Schneedecke – partiell entzieht. Der Wanderstab wird im Foto von Lewis allerdings emblematisch durch das Stativ mit der Filmkamera ersetzt. Im Film wird denn auch der Wanderer oder der betrachtende Künstler durch die Kamera ersetzt: objektive Erfassung anstatt subjektiv-romantische Naturbetrachtung. Niemand steht mehr im Bild: Die Landschaft kann sich unvermittelt entfalten. Die Kamera definiert den Fixpunkt im Bild, die Zoombewegung die Achse zum Betrachter. Bei Friedrich geht das Bild vom Wanderer aus, bei Lewis kommt es so nahe auf den Betrachter zu, dass dieser es als Bild erkennen kann.

Mark Lewis scheint in *Algonquin Park, Early March* die Wirkungsweise des radikalsten Werks von Caspar David Friedrich assimiliert zu haben: In *Der Mönch am Meer* (1809-10, Nationalgalerie Berlin) wird der Betrachter – und dessen Stellvertreter im Bild: der Mönch – mit einem schier endlosen Raum konfrontiert.

inverse correspondence to the gradual narrowing of the visual field. Even though *Algonquin Park, Early March* bears an allusion to Brueghel's winter landscape, this short sequence is not a painting. Rather, it indicates one of the possible approaches to a painting, that is, the film is a potential painting. Even the first minute of the March version of *Algonquin Park* clearly refers to the difference between the two media (film and painting): the shimmering white surface does not appear as a monochrome image but as a pure projection of light – or even as a disturbance? Whichever way it is interpreted, it suggests a missing image. Moreover, the room divider standing inside the gallery quite evidently does not play the role of pictorial support but that of a receiver of images.

Another very well-known painting that is both a precursor of *Algonquin Park, Early March*, and a means of transcending this work, is Caspar David Friedrich's *Wanderer Looking over the Sea of Fog* (ca. 1818, Kunsthalle Hamburg). Lewis closely studied this painting, as is demonstrated by a production still in which the Canadian artist can be seen turning his back to the viewer. He stands on a snow-covered rocky outcrop, looking out across a lake at his feet. Like Friedrich's wanderer, his body forms a dark outline in the centre of the composition, with his head touching the upper horizon. The two figures both stand above and inside the landscape, which – owing to the fog, or the snow-cover – is partially eluded. In Lewis's photo, however, the camera and tripod emblematically replace the walking stick. In the film, the camera replaces the wanderer, or the artist regarding the landscape: an objective recording supplants the subjectively romantic contemplation of nature. No human figure stands in the picture – the landscape presents itself without intermediary. The camera defines the fixed point of the image, while the zoom-motion defines the axis to the viewer. The starting point of Friedrich's image lies in the wanderer's gaze, while in Lewis's film the image moves towards the viewer until it can be interpreted as an image.

In *Algonquin Park, Early March* Mark Lewis seems to have assimilated the effects of Caspar David Friedrich's most

Caspar David Friedrich, *Elbschiff im Frühnebel / Boat on the Elbe in the Early Fog*, ca. 1821

radical work: in *Monk by the Sea* (1809-10, Nationalgalerie Berlin) the viewer – and his/her representative in the painting, i.e. the monk – faces what seems to be unlimited space. Friedrich's contemporary, Heinrich von Kleist made the following apt comment on this painting: "(...) and since [the painting] in its uniformity and boundlessness has no other foreground than the frame, looking at it is as though one's eyelids had been cut off." Mark Lewis has both multiplied and inverted this experience. In his work the foreground consists of nothing but scenery. The lakeshore is the frame. It is only when this frame has been captured in full that the white surface can be identified as a frozen lake. To adopt Kleist's observation, our "eyelids" are first stuck together and then are "cut off." At first, one sees nothing – nothing but shimmering white light. Then one sees a small section of what is most likely an immense landscape. The moving image of the film allows Lewis to empty the landscape both inwards and outwards, from inside out.

In or around 1821 Caspar David Friedrich – he again! – painted a series of rather small-format landscapes in the fog, *Boat on the Elbe in the Early Fog* (Wallraf-Richartz-Museum, Köln) among them. A critic made the following comment on this or a similar painting: "It is undeniable that nature occasionally appears in this way, but then it is not picturesque. It would only have become a picture some quarter of an hour later, when this shroud of fog would have sunk or been lifted." In other words, the painting represents a moment "before the picture", on whose development one can only speculate. The veil of fog promises to be raised. In majestic Cinemascope, *Algonquin Park, September* shows a foggy landscape with a boat entering from the right. In the background hovers the vague outline of an island or a spit of land. But the shroud of fog does not lift until the end of the film. The viewer's eye has to feel its way across the image, with its roiling fog, the phantom-like island and the delicate ruffles of the water. Nothing is revealed except these delicate sensations. It is possible to perceive Friedrich's foggy landscape as an "image before the painting". In contrast, thanks to the movement and despite a lack of action, Lewis's autumnal scene is not a "film before the film" – i.e., a film clip – but an autonomous "spectacle". The display of subtle atmospheric movements creates a fascinating, eminently painterly effect which is much closer to Turner than, as might have been expected, to Böcklin – that is, the Böcklin of the second version of the *Toteninsel* (Island of the Dead, 1983, Alte Nationalgalerie Berlin).

Although Mark Lewis's most recent works establish a very close relationship to painting, they are not paintings but

Von Friedrichs Zeitgenossen Heinrich von Kleist stammt folgende treffende Bemerkung zu diesem Gemälde: „(...) und da es [das Bild] in seiner Einförmigkeit und Uferlosigkeit, nichts, als den Rahmen zum Vordergrund hat, so ist es, wenn man es betrachtet, als ob einem die Augenlider weggeschnitten wären." Mark Lewis nun hat diese Erfahrung gleichzeitig potenziert und umgekehrt. Bei ihm bildet nichts anderes als die Landschaft den Vordergrund. Das Seeufer ist der Rahmen. Erst die vollständige Erfassung dieses Rahmens erlaubt die Identifizierung der weissen Fläche als gefrorenen See. Die „Augenlider", um Kleists Beobachtung weiterzuspinnen, sind einem zuerst verklebt und dann „weggeschnitten": Zuerst sieht man nichts – oder nur schillerndes weisses Licht –, dann nur einen knappen Ausschnitt aus einer vermutlich unermesslichen Landschaft. Das bewegte Bild des Films erlaubt es, die Landschaft nach innen und nach aussen, von innen nach aussen, zu entleeren.

Caspar David Friedrich – immer wieder er! – hat um 1821 eine Reihe eher kleinformatiger Nebellandschaften gemalt. Dazu gehört *Elbschiff im Frühnebel* (Wallraf-Richartz-Museum, Köln). Ein Kritiker schrieb über dieses oder ein ähnliches Bild: „Unleugbar erscheint die Natur manchmal so, aber dann ist sie nicht malerisch. Eine Viertelstunde später, wenn sich diese Nebelkappe hebt oder senkt, wäre erst ein Bild daraus geworden." Das Gemälde stellt also einen Moment „vor dem Bild" dar, über dessen Entwicklung man nur spekulieren kann. Der Nebelschleier verspricht, gelüftet zu werden. *Algonquin Park, September* zeigt im majestätischen Cinemascope-Format eine Nebellandschaft mit von rechts hereinfahrendem Boot. Im Hintergrund zeichnen sich zuweilen die vagen Umrisse einer Insel oder einer Landzunge ab. Doch der Nebelschleier lüftet sich bis zum Ende des Films nicht. Der Betrachter muss sich mit seinen Augen durch das Bild mit den ziehenden Schwaden, der phantomatisch aufscheinenden Insel und den feinen Kräuselungen des Wassers tasten. Ausser diesen feinen Sensationen wird ihm nichts offenbart. Konnte Friedrichs Nebellandschaft noch als ein „Bild vor dem Bild" betrachtet werden, so ist die Herbstszene von Lewis dank der Bewegung und trotz mangelnder Aktion nicht etwa ein „Film vor dem Film", d.h. ein Filmausschnitt, sondern ein autonomes „Spektakel". Das Schauspiel der subtilen atmosphärischen Regungen besitzt eine faszinierende, eminent malerische

Algonquin Park, September,
2001, production still

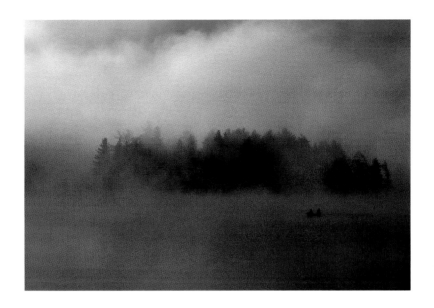

Wirkung, die viel mehr mit Turner als dem zu erwartenden Böcklin – dem Böcklin der *Toteninsel* in ihrer zweiten Version (1883, Alte Nationalgalerie Berlin) – zu tun hat.

Obwohl die neuen Arbeiten von Mark Lewis eine intensive Beziehung zum Bild herstellen, sind sie keine Bilder, sondern Filme. Sie haben einen Anfang und ein Ende. Sie besitzen eine Dauer. Sie enthalten Bewegung. Diese wird auf drei Arten erreicht, die kombiniert werden können: durch eine fahrende Kamera (das Travelling in *Children's Games*, *Heygate Estate*, die Steadycam in *Jay's Garden*); dann durch eine fix stehende Kamera, die aber technisch bewegt wird (das Zoom in *Algonquin Park, Early March*); und drittens durch eine fixe Kamera, die sich damit „begnügt", sich bewegende Objekte oder Personen einzufangen: fussballspielende Kinder, die ein Spielfeld streifenden Strahlen der sinkenden Sonne, durch Wind angetriebene Windräder und Gräser, einen die Landschaft von links nach rechts durchquerenden Reiter, winzige Schlittschuhläufer, sich im Wind sanft wiegende Bäume, Nebelschwaden, sich kräuselndes Wasser, einen Kanufahrer. Irgend eine menschliche Figur bewegt sich immer. Sie ist das filmische Äquivalent der Staffagefigur in der klassischen Landschaftsmalerei, die einerseits den Massstab zur Landschaft liefert, andererseits aber auch das Bild als „bewegtes" kennzeichnen soll. In Lewis' Filmen ist sie der manifestste Indikator von Zeit, d.h. von Bewegung im Raum und kann gar den Anfang oder das Ende eines Films determinieren.

films: they do have a beginning and an ending. They have a duration; they contain movement. This movement is achieved in three different ways, which are occasionally combined: there is the travelling camera (as in *Children's Games*, *Heygate Estate*, or the steadycam in *Jay's Garden*); then there is a static camera which is, however, moved technically (the zoom in *Algonquin Park, Early March*); and, finally, there is the fixed camera "resigned" to capturing moving objects or people, such as children playing football, the setting sun whose last rays touch a playground, blades of grass and wind turbines set in motion by the wind, a horseman riding across the scenery from left to right, minute skaters, trees swaying gently in the wind, eddies of fog or water, a canoeist. There is always some human figure moving about somewhere. It is the filmic equivalent to the "extra" in classic landscape painting, which not only provides the human dimension but also signals "movement". In Lewis's films the human figure is the most explicit indicator of time, that is, of movement in space; it may even define the beginning or the ending of a film.

47

Die Kreisbewegung ist ein durchgängiges Motiv bei Mark Lewis. *North Circular* besteht zwar aus einer Kamerafahrt vorwärts, doch endet die Einstellung mit einem *close-up* auf einen Kreisel, der eine Anspielung auf den Drehort in London – er bildet den Filmtitel – darstellt. In *Smithfield* fährt die Kamera vorwärts, dann rückwärts um ein Gebäude mit dreieckigem Grundriss und halbkreisförmigem Eingang. *Wind Farm* besteht aus einem Ballett Dutzender rotierender Windräder, die das Drehen der Filmspule in der 35mm-Kamera zu imitieren scheinen. Ein Kranz von Bäumen umzingelt langsam das weisse Bild in *Algonquin Park, Early March*.

The circular movement is a recurring motif in Mark Lewis's work. Although *North Circular* consists of a tracking shot in, the take ends in a close-up of a spinning top, an allusion to the – eponymous – location in London where the film was made. In *Smithfield*, the camera travels first forward, then reverses around a triangular building with a semi-circular entrance. *Wind Farm* presents a ballet of dozens of rotating wind turbines which appear to imitate the film reel in the 35mm camera. In *Algonquin Park, Early March*, trees gradually encircle the white expanse. Mark Lewis's films are all relatively short loops: as soon as they have ended, they start afresh. Indeed, Lewis is often concerned with movement itself, with temporalising the image through movement.

Die Kreisbewegung ist in Mark Lewis' Werk omnipräsent. Dazu werden alle Filme dieses Künstlers als relativ kurze Loops präsentiert: Kaum sind sie zu Ende, beginnen sie wieder von vorne. Lewis geht es in der Tat oft um die Bewegung selbst, um die Verzeitlichung des Bildes durch die Bewegung.

A film is both more and less than a painted image. As Luc Tuymans recently stated in an interview, "... painting is like the reverse of film because a painting contains all images: painting can make something appear and disappear at the same time[2]." The expression "at the same time" is relevant here: in the film, something appears and disappears gradually, albeit frame by frame. Here, it is possible to witness the appearance and disappearance of an image – didactically, as it were. Mark Lewis's films address Becoming and Passing, their own becoming and passing; they show time, their own time, prescribing a time that is different from time – a time that passes too slowly, a time that is turned in upon itself.

Ein Film ist einerseits mehr und andererseits weniger als ein gemaltes Bild. Luc Tuymans sagte kürzlich in einem Interview: „ ... die Malerei ist ja wie das Umgekehrte des Films, weil in einem Gemälde alle Bilder enthalten sind: Malerei kann etwas erscheinen und gleichzeitig verschwinden lassen."[2] Wichtig ist hier das Wort „gleichzeitig". Im Film taucht etwas nach und nach, kontinuierlich wenngleich Bild für Bild, auf oder wieder unter. Hier ist es möglich, dem Auftauchen und Verschwinden des Bildes direkt – quasi didaktisch – beizuwohnen. Die Filme von Mark Lewis thematisieren das Werden und Vergehen, ihr eigenes Werden und Vergehen; sie zeigen Zeit, ihre eigene Zeit. Sie schreiben der Zeit eine andere Zeit vor – eine Zeit, die zu langsam verrinnt; eine Zeit, die sich um sich selbst dreht. Handelt es sich beim Unterfangen von Mark Lewis vielleicht um einen Versuch, die durch seine unlimitierte Reproduzierbarkeit verlorene Aura des Films zurückzugewinnen? Vom Betrachter anstatt „Zerstreuung" wieder „Sammlung" zu fordern? Walter Benjamin bemerkt in seiner berühmten Schrift *Das Kunstwerk im Zeitalter seiner technischen Reproduzierbarkeit*, die meistens nur im Zusammenhang mit der Fotografie herangezogen wird, obwohl sie doch den Film als die Errungenschaft des technischen Zeitalters erkennt: „Die Rezeption der Zerstreuung, die sich mit wachsendem Nachdruck auf allen Gebieten der Kunst bemerkbar macht und das Symptom von tiefgreifenden Veränderungen der Apperzeption ist, hat am Film ihr eigentliches Übungsinstrument." Die Wahrnehmung, die Lewis' Filme verlangt, ist das Gegenteil von Zerstreuung. Ist sie nicht vergleichbar mit der Wahrnehmung eines gemalten Bildes?

Might Mark Lewis be attempting to restore to film the aura that it has lost because of its unlimited reproducibility? Or is he demanding viewers to be "contemplative" rather than "distracted"? Walter Benjamin makes the following remark in his famous treatise, *The Work of Art in the Age of Mechanical Reproduction*, which is most often quoted in the context of photography, although it identifies film as the achievement of the technical age: "Reception in a state of distraction, which is increasingly noticeable in all fields of art and is symptomatic of profound changes in apperception, finds in the film its true means of exercise." The perception that Lewis's films demand is the opposite of distraction; it is perhaps comparable to the perception that a painted image would require.

2. In *Das Kunst-Bulletin* 12, 2002, p. 15.

Jay's Garden, Malibu, 2001, Kunsthalle Bern

Translation from German: Margret Powell-Joss

2. In *Das Kunst-Bulletin* 12, 2002, S. 15.

Jay's Garden, Malibu, 2001,
Kunsthalle Bern

52

Jay's Garden, Malibu, 2001,
Kunsthalle Bern

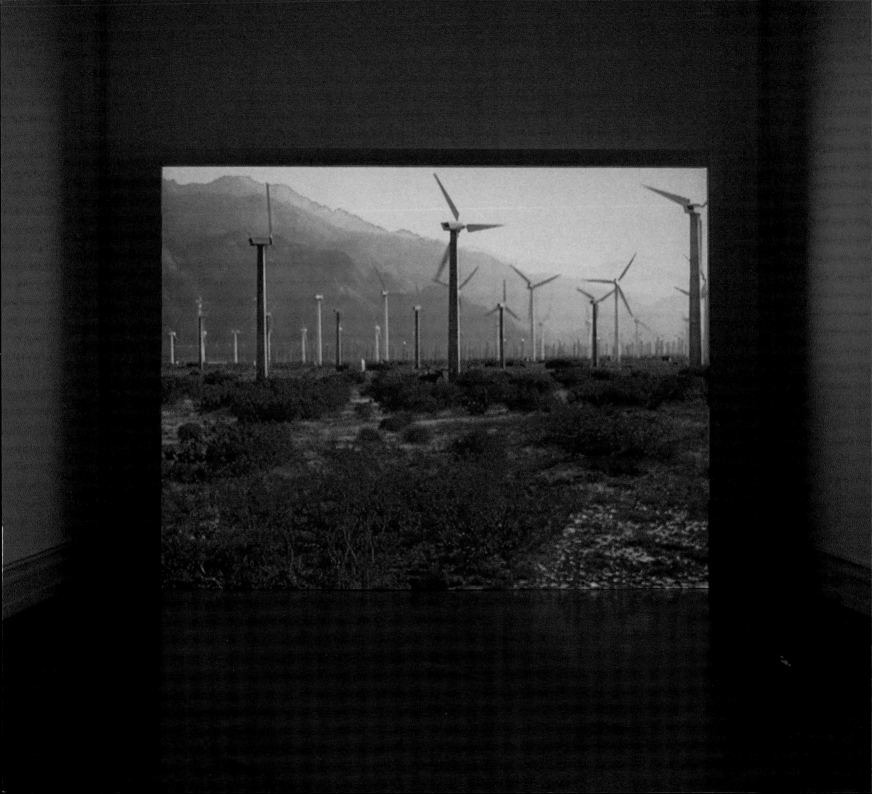

Solo Exhibitions
Einzelausstellungen

2003
Rooseum, Malmö,
curated by Charles Esche
Sale Recalda, Bibao*,
curated by Chuz Martinez

2002
Galerie Cent8, Paris
Centro de Art Salamanca, Salamanca,
curated by Christina Zelich
Kunsthalle Bern,
curated by Bernhard Fibicher*
argos, Brussels,
curated by Paul Willemsen*

2001
Villa Arson, Nice,
curated by Laurence Gateau*
Museum of Modern Art, Oxford,
curated by Astrid Bowron*
Rhona Hoffman Gallery, Chicago
Galerie Cent8, Paris
Or Gallery, Vancouver,
curated by Reid Schrier and Damien Moppet
Marché Bonsecours, Montreal,
organized by Vox Populi, Mois de La Photo,
curated by Marie José Jean*

2000
National Gallery of Canada, Ottawa, curated by
Janice Seline*
MAMCO (Musée d'art moderne et contemporain),
Genève,
curated by Catherine Pavlović
Fig-1, London,
curated by Mark Francis*
Quartier Éphémère, Montreal,
public projection, curated by Caroline Andrieux
Patrick Painter Inc., Los Angeles
(Mark Lewis and Paul McCarthy)
Norwich Gallery, Norwich,
curated by Steven Bode and Linda Morris*
Site Gallery, Sheffield,
curated by Steven Bode and Carol Maund*

1999
Attitudes, Genève,
curated by Olivier Kaeser
Institute of Visual Arts, Milwaukee,
curated by Jerôme Sans
Patrick Painter Inc., Santa Monica

1997
Vancouver Art Gallery, Vancouver
Patrick Painter Inc., Santa Monica

1996
Tramway, Glasgow,
curated by Charles Esche
Blum and Poe, Los Angeles

1994
UBC Fine Arts Gallery, Vancouver,
curated by Scott Watson*
Cold City Gallery, Toronto,
Haags Centrum voor Aktuele Kunst (HCAK),
Den Haag,
curated by Phillip Peters*

* Catalogue / Katalog

Wind Farm, 2001,
Kunsthalle Bern

Selected Group Exhibitions
Gruppenausstellungen, Auswahl

2003
Re-Makes, CAPC Musée d'art contemporain,
Bordeaux*
La nouva agora, Shedhalle, Zürich,
curated by Dagmar Reichert*
[based upon] TRUE STORIES, Witte de With,
Rotterdam,
curated by Catherine David and J. P. Rhem*
The American Effect, Whitney Museum of American
Art, New York
curated by Larry Rinder*
Sodium Dreams, CCS Museum, Bard College,
Annandale on Hudson,
curated by Elizabeth Fisher*
Happiness: a Survival Guide for Art and Life,
Mori Art Museum, Tokyo,
curated by David Elliot and Pierluigi Tazzi*
Various Properties, Belkin Art Gallery, Vancouver
Landscape, Kiasma, Helsinki*,
curated by Maaretta Jaukkuri
Fate of Alien Modes, Sezession, Wien*,
curated by Constanze Ruhm

2002
The Liverpool Biennial, International Exhibition,
Tate Liverpool,
curated by Lewis Biggs, Eddie Berg, et al*
The Mind is a Horse, Bloomberg Space, London
Gwangju Biennale, Gwangju,
curated by Hou Hanru, Charles Esche*
Cine y casi cine, Museo Centro de Arte Reina Sofia,
Madrid,
curated by Berta Sichel
Non-places, Frankfurter Kunstverein,
Frankfurt,
curated by Nicolaus Schafhausen and Vanessa
Muller*
Spectator Sport, Cornerhouse, Manchester,
curated by Steven Bode and Paul Bailey*
Not a Film, Galerie Tent, Rotterdam,
Landscape, Maison de la Culture, Bruges,
curated by Hubert Bescier
Unprincipled Desires, John Hansard Gallery,
Southampton,
curated by Stephen Foster
La nouva agora, Fondazione Pistoletto, Biella,
curated by Dagmar Reichert

2001
Endtroducing, Villa Arson, Nice,
curated by Laurence Gateau*

2000
Intelligence: New British Art 2000, Tate Britain,
curated by Charles Esche and Virginia Button*
Wouldn't it be Nice, Montevideo, Amsterdam,
curated by Marieka Van Hal
Third Taipei Biennial of Contemporary Art, Taipei
Museum of Fine Art, Taipei,
curated by Jerôme Sans and Man Ray Hui*
Pictures, Positions and Places, Vancouver Art Gallery,
Vancouver

1999
Cinema! Cinema! The Cinematic Experience,
Van Abbemuseum, Eindhoven,
curated by Jaap Guldemond*
Imago 99, Centro de Fotografia,
Universidad de Salamanaca, Salamanaca*
Objects in the Mirror are Closer Than You Think,
Galerie Max Hetzler, Berlin,
curated by Wolfram Aue
Moving Images – Filme und Reflexion in Der Kunst,
Galerie für zeitgenössische Kunst, Leipzig,
curated by Jan Winckelman*
Dis.location, Kulturbüro Stadt Dortmund and
Montevideo, Amsterdam
Dots and Loops, MK Galerie, Rotterdam,
curated by Jason Coburn

1998
Artificials, Museu d'art contemporani Barcelona
(MACBA)*,
curated by Jose Labrero Stals*
New Work, Patrick Painter Inc., Los Angeles
Programme for Art on Film, Brooklyn Museum,
New York

1997
Tampering with the Reel, Artists Space,
New York,
curated by Pit Bay
Vancouver International Film Festival, Vancouver
One Minute Scenario, Printemps de Cahors, Cahors,
curated by Jerôme Sans*
Artists working with Film, Spot Gallery, New York,
curated by Warren Neidich
Festival International du Film sur l'art, Montreal,
(jury prize)
Rotterdam International Film Festival, Rotterdam
Architectural Expressions, Vancouver Art Gallery,
Vancouver,
curated by Bruce Grenville

1996
Les contes de fées se terminent bien, Fonds régional
d'art contemporain de Haute Normandie, Rouen,
curated by Alexandra Midal*
Nomadia, De Vaalserberg, Rotterdam*
Reading and Re-reading, Oakville Galleries,
Oakville*

1995
L'Effet cinéma, Musée d'art contemporain,
Montreal,
curated by Real Lussier*
Irresistable Liasons, Mecano, Amsterdam,
curated by Nelly Voorhuis
Film and Arc Graz, Graz

1994
*The Human Condition: Hope and Despair
at the End of the Century*, The Spiral Building
(Wacoal Art Center), Tokyo,
curated by Nanjo Fujimo and Dana Friis-Hansen*

1993
Viennese Story, Wiener Secession, Wien,
curated by Jerôme Sans*

* Catalogue / Katalog

Credits

for Mark Lewis's films shown at argos, Brussels and Kunsthalle Bern
für die bei argos, Brüssel und in der Kunsthalle Bern gezeigten Filme von Mark Lewis

Centrale, 1999

Cast
Lucy Whybrow, Roger Wright, Jonathon Viner, John Hun, Janice Kerbel, Pernille Leggat Ramfert

Crew
Director of Photography: Oleg Poupko
First Assistant Camera: Jenny John Chung
Production Manager: Bevis Bowden
Assistant production Manager: Matt Randall
Runner: Gary Fischer
Gaffer: Paul Sharp
Photography: Janice Kerbel
Colour Timer: Tareq at VTR

North Circular, 2000

Cast
Ashley Walters, Sid Mitchell, Roland Manookian

Crew
Producer: Johann Insanally
Assistant Producer: Maureen Blackwood
Director of Photography: Tim Palmer
1st Assistant Director: Mark Fenn
Camera Assistant: Jo Blackwell
Clapper/loader: Steve Janes
First Grip: Dennis Dillon
Second Grip: Les Spring
Gaffer: Richard Barber
Crane Driver: Clive Tocher
Production Assistant: Grant Cummings
Runner: Yvonne Connikie
Wet Down FX: Bob Smoke Effects/Bernie Newton
Crew Bus: Karen @ Filmflow
Cameras: John Rendall and Rob Garvey
Tracking Vehicle: Bickers/Paul Bickers and Dean Cox
Colour Timer: Jamie Wilkinson at VTR

Wind Farm, 2001

Cast
Wind-farmer: Charisse Glenn

Crew
Director of Photography: Neal L. Fredericks
1st Assistant Camera: Joe Solari
2nd Assistant Camera: John Grondorf
Gaffer: Dale Obert

Production Runner: Karl Erikson
Producer: Patrice Bilakwa
Production Assistant: Mary Jane Church
Horse Wrangler: Carl Mergenthaler
Colour Timer: Jamie Wilkinson at VTR

Jay's Garden, Malibu, 2001

Cast
Nikita Denise, Dee, Ginger, Kim Chambers, Brad Armstrong, Syn, Steve Hatcher, Sydnee Steele, Tiger, Kristal Summers, Devinn Lane, Scott Styles, Jonathan Morgan, Julia Ann, Solveig

Crew
Producers: Michael Amato and Ted Schipper
1st Assistant Director: Tommy Kuk
Prop Master: Chris Kas
Production Runners: Colin McKean, Valerie Schultz and Alex Munoz
Casting: Joy King/Wicked Pictures
Director of Photography: Neal L. Fredericks
Steady-Cam Operator: Jon Myers
1st Assistant Camera: Joe Solari
2nd Assistant Camera: John Grondorf
Stills Photographer: Karl Erikson
Gaffer: Dale Obert
Key Grips: Brian Scotti and Brian Hart
Make-Up Artists: Robin Mathews and Stacy Rae
Catering: Sandy Townsend

Production Assistance: Villa Arson, Nice, France
Garden designed by: Jay Griffith

Thanks to: Jay Griffith, Laurence Gateau, Deborah Irmas, Joy King and Bernhard Starkmann

Algonquin Park, Early March, 2002

Cast
Josh Bruner, Terry Bruner, Will Bruner, Andrew Candow, Brett Coon, Carly Dodgson, Andrew Fisher, Chris Helgason-Roff, Brendan Jarrett, Michael Kirkpatrick, Mark Looker, Allan Maclean, Molly Morin, Jessican Nairn, Ron Nairn, Meagan Nunn, Tom Nunn, John Peace-Hall, Matt Rice, Kyle Stone

Crew
Producer: Stacey DeWolfe
Cinematographer: Tony Geurin
Camera Assistant: Paul Begin
Production Assistants: Allan Bradley, Bryan Burt, Michael Girard, Malcolm Fraser, Gregg Hunter, Matthew Hunwicks, James Jack, John Keough, Jörg Schmidt, Adam Traynor, John Yemen
Safety Coordinator: Havoc Stunt Services International - Richard Collier and Simon Northwood

Park Rangers: Brian Ostrokie and Paul Shalla
Consultant: Mary Ellen Peace-Hall
Dog Sled: Venture Out Expeditions – Peggy
Billingsley

Commissioned by the Liverpool Biennial
International Exhibition, 2002

Tenement Yard, Heygate Estate, 2002
Children's Games, Heygate Estate, 2002

Cast
Natalie Abban, Tessa Allen-Ridge, Ewan Alman,
Olivier Austin, Katrina Bright, George Brown,
Jeana Cachero, Christopher Charles, Micky
Churchill, Terry Dumont, Harry Eden, Leona
Ekembe,
Vicki Elliot, Adrien Fergus-Fuller, Leah Fitzgerald,
Troy Glasgow, Levi Hayes, Sarah Hayward,
Charlotte Hilton, Jerome Holder, Snow Hsu,
Nanya Ikechi, Rhys Jones, Karl Joseph,
Jody Latham, Lucy Manners-Briggs, Chloe Mitchell,
Freddie Mitchell, Tracey Murphy, Sonny Muslim,
Emma Nakatani-Brown, Serena Nakatani-Brown,
Biana Neil, Michael Pelluso, Corina Stegner,
James Stennett, Kandace Walker, James Ward,
Bronson Webb, Eliot Worth

Crew
Production coordinator: Bevis Bowden
Production assistant: Alistair Whyte
Director of Photography: Martin Tester
Stedicam operator: Simon Baker
Focus Puller: Tony Stanier
Clapper Loader: Adam Roberts
Grip Luco
Casting Director: Chloe Emmerson
Assistant Casting Director: Dixie Chassay
Location Manager: Matt Lane
Location Cast Manager: Nina Ernst
Assistant Location Cast Manager: Pernille
Leggat Ramfelt
1st Assistant Director: Griffin
2nd Assistant Director: Lisa Butler
3rd Assistant Director: Paul Cathie
Runners: David Carbone, Alalia Chetwynd,
Helen Jillot, Stella de la Sauce

Co-commisssioned by Film and Video Umbrella
and Cornerhouse, in association with the Centro
de Arte de Salamanca and Rooseum, Malmö.
With the support of the Culture 2000 programme
of the European Union.

Mark Lewis would like to thank
the following persons and institutions
for their support:
*Mark Lewis möchte folgenden Personen und
Institutionen für ihre Unterstützung danken:*

Liverpool Biennial, International Exhibition
Canada Council for the Arts
Villa Arson, Nice
Central Saint Martins College of Art and Design,
London
Ministère de la Culture et de la Communication,
Délégation aux Arts Plastiques, Paris
The Millenium Fund of The Canada Council
for the Arts

Steven Bode; Film and Video Umbrella;
Laurence Gateau; Villa Arson; Bernhard Fibicher;
Piet Coessens; Paul Willemsen; Mira Sanders;
argos; Bevis Bowden; Martin Tester; Joy King;
Wicked Pictures, Chatsworth, California;
John Winters; Algonquin Provincial Park, Ontario
Canada; Jay Griffith; Michael Amato;
Ted Schipper; Stacey DeWolfe; Fraser Robinson;
Serge Le Borgne; Neal Fredericks; Janice Kerbel;
Roger Larry; Chris Wainwright; Charles Esche

Diese Publikation erscheint
aus Anlass der Ausstellungen von Mark Lewis in argos, Brüssel,
18. Mai – 29. Juni 2002,
Kurator: Paul Willemsen
und in der Kunsthalle Bern, 6. September – 13. Oktober 2002,
Kurator: Bernhard Fibicher

This catalogue was published
on the occasion of Mark Lewis's exhibitions held at argos, Brussels,
18 May – 29 June 2002,
curated by Paul Willemsen
and at Kunsthalle Bern, 6 September – 13 October 2002,
curated by Bernhard Fibicher

argos
Werfstraat 13 rue du Chantier
B –1000 Brussel/Bruxelles
www.argosarts.org

Kunsthalle Bern
Helvetiaplatz 1
CH-3005 Bern
www.kunsthallebern.ch

Graphic design: Pierre Neumann, Vevey

Translations/Übersetzungen: Margie Mounier, Margret Powell-Joss

Photo credits: Dominique Uldry, Bern
David Lambert/Rod Tidnam, Tate Liverpool
Jan Kempenaers, Antwerpen
Janice Kerbel; Stacey de Wolfe
all location photographs by Mark Lewis

Scans/Photolithos: Ast + Jakob AG, Köniz

Printing/Druck: die keure, Brugge

© 2003 argos editions, Kunsthalle Bern,
the artist, the authors and translators

ISBN 90-76855-14-5
D/2003/9073/1

Printed in Belgium